Conundrum

Conundrum

Puzzles in the
Grotesques
Tapestry Series

Charissa Bremer-David

The J. Paul Getty Museum
Los Angeles

CONTENTS

FOREWORD

The subject of this study is a series of tapestries whose design was broadly appealing and enormously successful but whose multilayered subject was mysterious and deliberately puzzling. Indeed, the complexity of its visual motifs posed an intellectual and visual conundrum that is still being decoded. The true meaning of the series has remained elusive, and no one has definitively identified its subject. One point is certain: there is still much to learn and to appreciate about the series. Delighting the eye and engaging the mind, this book takes us a long way toward that understanding.

Conceived and designed by 1688 for a tapestry manufactory in the French town of Beauvais, the *Grotesques* series enjoyed a highly profitable production for more than four decades. Indeed, the popularity of the hangings persisted much longer, across centuries, as attested by the number of examples preserved today in private and public collections in both Europe and the United States. Of the estimated 300 pieces originally woven, some 150 survive, four of them in the J. Paul Getty Museum. Three of these have never been included in a scholarly review until now.

Charissa Bremer-David, curator of sculpture and decorative arts at the J. Paul Getty Museum, commenced an exploration of the *Grotesques* in the 1997 catalogue *French Tapestries and Textiles in the J. Paul Getty Museum*.

Subsequent detective work by her built upon this foundation, richly facilitated by the wealth of resources in the Research Library and Special Collections of the Getty Research Institute, a sister program of the J. Paul Getty Trust. The fruits of this research lend a new dimension to the extravagant richness and beauty of the tapestries themselves, for which we are all in the author's debt.

Rebecca Vera-Martinez, senior photographer, and Johanna Herrera, senior imaging technician, contributed handsome illustrations to the sumptuous visual presentation of this book. The text has been deftly edited by Tom Fredrickson. Kurt Hauser, senior graphic designer, and Amita Molloy, senior production coordinator, created the elegant design. Elizabeth Nicholson, editor in chief, ably guided the entire project.

Timothy Potts, Director
J. Paul Getty Museum

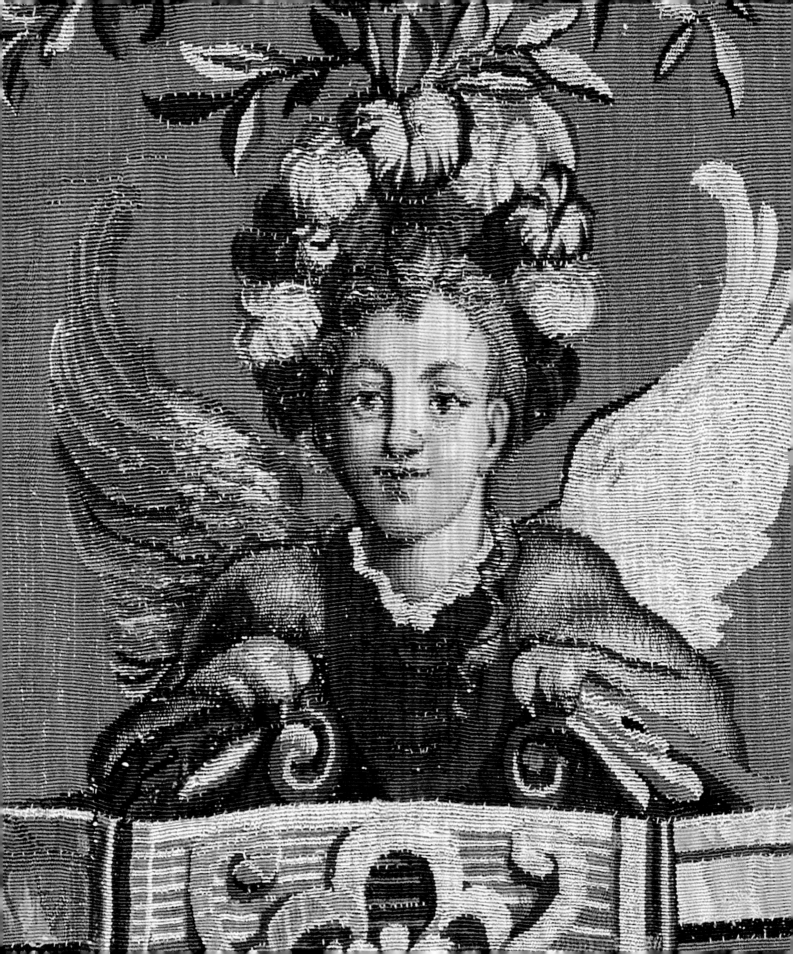

Grotto A large and deep hollow found naturally
formed in a mountain or rock. One finds rock crystals
and many other congealed formations in grottos. The
word comes from *crypt*. . . . *Grotto* also refers to the
small artificial buildings that one makes for gardens
that imitate nature and are adorned with shells or
have fountains. The *grotto* [of Thetis] at Versailles is an
excellent example of such architecture. . . .

Grottesque A whimsical figure in painting, in engrav-
ing, in sculpture, which has something of the ridicu-
lous, extravagant, or monstrous, as in the manner of
grottos. . . .

Grottesques A word used for figures who are bizarre,
extravagant, ridiculous in themselves, in their habits,
in their speech, etc. One painted the pagan gods in a
thousand *grottesque* figural ways. Costumes from mas-
querades and ballets are more esteemed the more
they are *grottesque*.

—Antoine Furetière, *Universal Dictionary, Generally Containing All Words*,
(*Dictionnaire universel, contenant généralement tous le mots*), 1690[1]

"While [Giovanni da Udine] improved daily under the
guidance of Raphael, excavations in the ruins of the
Palace of Titus [uncovered] . . . some painted chambers
of Grotesque, that is to say of small figures, which do
not always resemble an entire man and animal as one
would like to represent them, but they have some-
thing of the chimerical.

—André Félibien, *Discussions concerning the Lives and Works of the Most Excellent
Painters, Ancient and Modern*, (*Entretiens sur les vies et sur les ouvrages des plus
excellents peintres anciens et modernes*), 1672[2]

INTRODUCTION

In the late 1680s the French royal
tapestry manufactory at Beauvais,
some forty miles north of Paris,
conceived and executed a series
of tapestries of highly innovative
design. Identified in contemporary
documents as the *Grotesques*, the
series became enormously popular,
with some fifty sets of tapestries
(each typically composed of six
hangings) woven during its forty-year
production run. Of these, about 150
individual pieces survive today in
private and public collections, includ-
ing four in the J. Paul Getty Museum
that are discussed in the following
pages (Tapestries 1–4).[3] This book
recounts the invention of the series
and reveals the visual sources that
inspired so many of its composi-
tional details in order to explore and
explain its brilliant originality and
success.

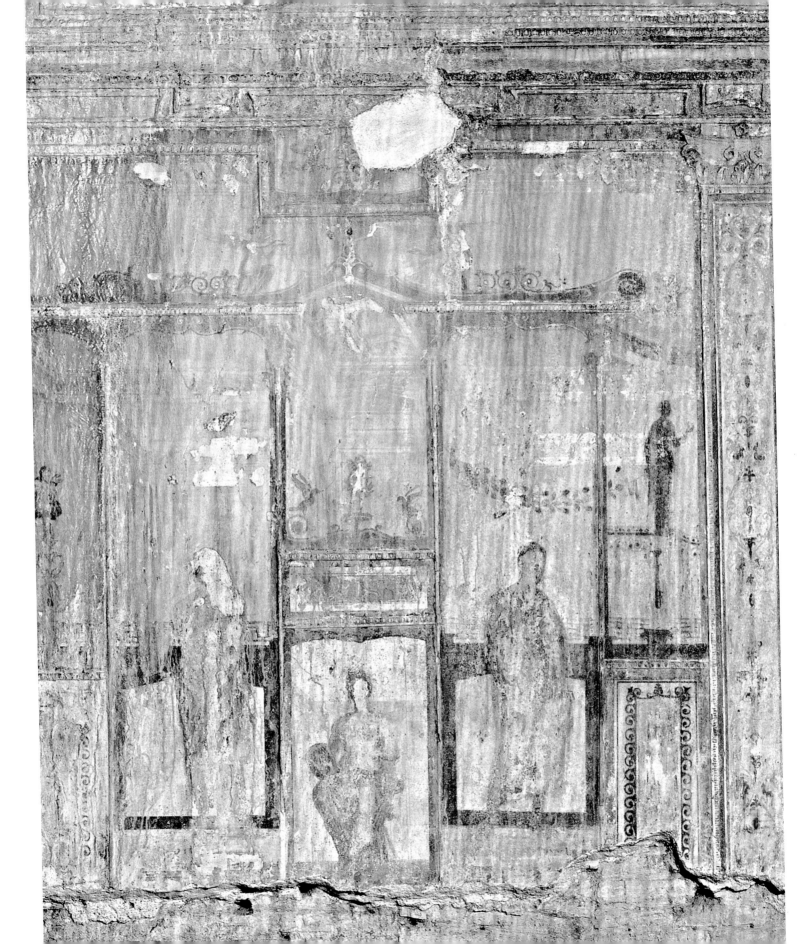

The meaning of *grotesque* as it was understood in the late seventeenth century differs from our current understanding of the word, which, with its modern association and conflation with the slang word *gross*, conveys an unpleasant sense of disgusting ugliness or crude coarseness. In the late 1600s *grotesque* had multiple subtle meanings, not all of which survive in today's common usage. Originally derived from the word *grotto*, the adjective *grotesque* described unusual natural stone formations and rocky textures of the type encountered in caves and that were replicated in man-made environments, most often in garden settings.

It has been argued that the basic composition, and perhaps even the deep-orange ground color, of the *Grotesques* tapestries took inspiration from the antique genre of decoration rediscovered when, in the 1480s, underground cave-like excavations exposed remains of an ancient Roman palace, the so-called Golden House, or Domus Aurea, built in the first century AD for Emperor Nero (r. 54–68).[4] Those excavations revealed spaces that were likened to grottos. The partially extant and yellowed-with-age wall and ceiling fresco decorations preserved within portrayed classical pagan deities standing under pavilions or in geometric compartments and hybrid mythological creatures contained within running borders (fig. 1). This new-found style prompted Renaissance artists—most notably Raphael (1483–1520)—and generations of their stylistic successors to revive and reinterpret the genre then called *grotesque*.[5] Tapestries in this taste were first made as early as 1521 after cartoons by a student and assistant of Raphael for Pope Leo X (r. 1513–21). The Beauvais tapestries followed in this tradition.

The Beauvais tapestry series, however, also drew from contemporary musical and theatrical trends to give added distinction, meaning, and currency to the manufactory's version of the style. For instance, the series' designer, Jean-Baptiste Monnoyer (1636–1699), playfully alluded to another seventeenth-century definition of *grotesque* that described a form of entertainment in which a pastiche of acts was performed by singers, musicians, ballet dancers, actors, and acrobats, sometimes masked. As this type of performance evolved from the French court ballets of the 1650s to the witty Parisian comedy ballets of the 1660s and 1670s, the moderately mocking spectacles were called *burlesques, crotesque musicals,* and *masquerades.* Such performances blended high and low theatrical styles, interspersing narratives of lofty heroic virtue and mythological accounts of triumphant gods with nondramatic interludes inspired by the improvised skits from the commedia dell'arte and popular street-fair raillery.[6] The Beauvais *Grotesques* tapestry series likewise alternated traditional visual expressions of divine power with lighthearted music, dance, and character types from a range of comic repertoires.

In addition, Monnoyer incorporated dozens of motifs and vignettes borrowed from visual sources that were available to him as he worked in and around Paris. He was deeply immersed, and indeed was a participant, in the contemporary art scene. He was familiar with French royal commissions for casts after antique sculpture, the classicism of painters Nicolas Poussin (1594–1665) and Charles Le Brun (1619–1690), the arabesque ornament of Jean Bérain the Elder (1640–1711), the animal portraits of Pieter Boel (1622–1674), and court fashion of Versailles. Monnoyer's designs for the Beauvais *Grotesques* tapestries smoothly integrated disguised details from such diverse elements as antique

Figure 2
Tapestry, *The Offering to Bacchus* from *The Grotesques*, French (Beauvais manufactory), after the design by Jean-Baptiste Monnoyer (French, 1636–1699), border after the design of Jean-Baptiste Monnoyer and Guy-Louis Vernansal (French, 1648–1729), ca. 1688–1732. Wool and silk, modern cotton lining, 295.3 x 204.5 cm (116½ x 80½ in.). Los Angeles, J. Paul Getty Museum, 86.DD.645

statuary, Renaissance books and prints, Baroque art, contemporary seventeenth-century court spectacle, and Parisian ballet and opera. These embedded visual puzzles have largely eluded art historians due to the overall decorative nature of the series. Revealing and decoding these conundrums help us to recognize the broad and witty intellectual underpinnings of the series.

DESIGN AND STYLE

The ingenious design of the Beauvais *Grotesques* tapestries manipulated space and color in an innovative and intriguing manner. Visually, the Beauvais *Grotesques* were—and still are—arresting for their shallow foregrounds set simply and boldly against a flat, planar field of deep orange (fig. 2).[7] The foreshortened, stagelike compositions were oddly pleasing to the eye, even though they lacked the traditional, illusionistic recession of space from middle- to background. The protagonists, both human and animal, were not monumental in scale but rather appropriately proportioned within their fictive arcades. Moreover, the vertical and lateral dimensions of each composition were flexible. They could be executed in taller or shorter heights and wider or narrower widths by

including or excluding fringe figures, architectural elements, or ornamental strap work, swags, and vases. Once the height for a set of tapestries was fixed, the widths of the individual pieces could be customized to the patron's specifications. This flexibility, as well as a choice of at least six border types, allowed the manufactory to create countless variations of the tapestries, correspondingly priced, that catered to a wide variety of customers across socioeconomic rank and geographic range.[8]

Despite the success of the series, contemporary documentation concerning it is fragmentary. We know that production began at the Beauvais tapestry manufactory under the direction of Philippe Béhagle (1641–1705) by 1688 at the latest. By the following February, in 1689, Béhagle offered as partial collateral for a debt four tapestries woven with gold thread from two sets then in progress, each destined to contain six tapestries. Called "grotesques with small-scale figures" in the notary document, their combined value was given as 2,700 livres (or pounds, a monetary unit).[9] This is the earliest record of the Beauvais series. It is interesting to note that the series was described by the term *grotesques* from this first instance. (No examples

of Beauvais *Grotesques* with metallic thread are known to survive.)

We next learn the identity of the designer of the series and the specific nature of the grotesque motifs from the correspondence of Daniel Cronström (1655–1719), a Swedish envoy living in Paris, who wrote in a letter to the architect Nicodemus Tessin the Younger (1654–1728) in January 1695: "If I were not afraid of giving you an overly attractive idea of things, I would tell you that the Beauvais *Grotesque* and the *Seaports* are the loveliest sets [of tapestries] one can ever see at those prices. . . . Of the *Grotesque* that they sell as tapestry here . . . it is of the design of Baptiste, the excellent painter and ornamentalist. It is in the taste of those from the Gobelins made after the designs of Raphael in Rome."[10]

Thus, we see that the term *grotesque*, as used in the notary document and in the Cronström-Tessin correspondence, was equated with a style of tapestries then in production at the French royal manufactory at the Gobelins, in Paris, after the designs of Raphael from his Roman period (1508–20). This can only refer to the Gobelins program to reweave the older and much admired series called *The Triumphs of the Gods*, or *The Grotesques of Leo X*, named for

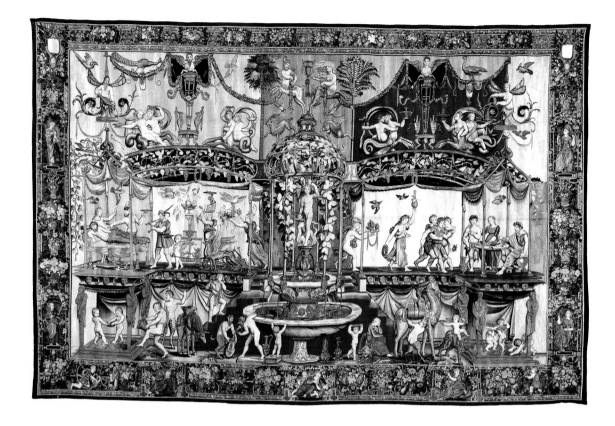

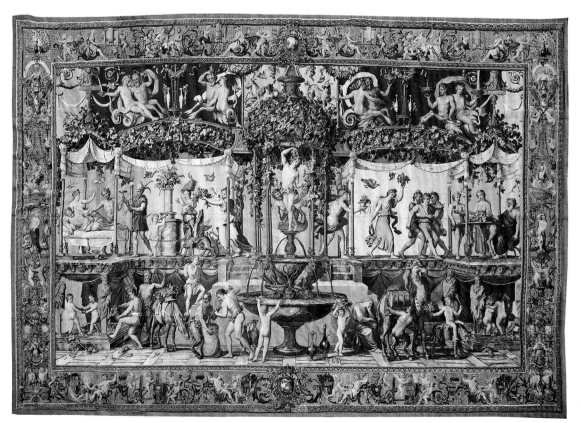

Figure 3

Tapestry, *The Triumph of Bacchus* from *The Triumphs of the Gods,* Flemish (Brussels, Frans Geubels workshop), after the cartoon by Giovanni da Udine (Italian, 1487–1564), ca. 1560–70. Wool, silk, and metallic thread, 495 x 764 cm (195 x 300¾ in.). Paris, Mobilier National, GMTT 1/3

Figure 4

Tapestry, *The Triumph of Bacchus* from *The Triumphs of the Gods,* French (Paris, Gobelins manufactory), after the design of Noël Coypel (French, 1628–1707), 1702–08. Wool, silk, and metallic thread, 485 x 690 cm (191 x 271½ in.). Paris, Mobilier National, GMTT 2/1

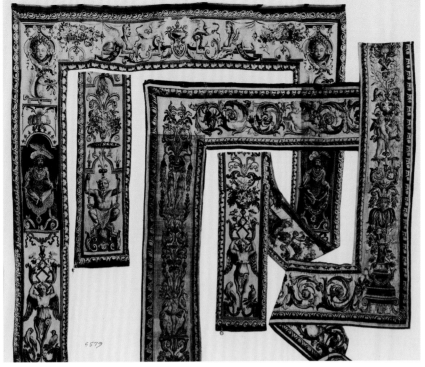

Figure 5
Tapestry, Chinoiserie and Rinceaux Borders, French (Beauvais manufactory), the former after the design by Jean-Baptiste Monnoyer (French, 1636–1699) and Guy-Louis Vernansal (French, 1648–1729), ca. 1688–1732. Wool and silk, unknown dimensions. Los Angeles, Getty Research Institute, Study Photographs of European Tapestries 97.8.7, French & Company, stock numbers 5579 and 5576

the Medici pope who commissioned them (Leo X, born Giovanni de Lorenzo de' Medici, 1475–1521). That series consisted of eight designs: six triumphant Roman gods and two other subjects, *Grammar among the Liberal Arts* and *Faith among the Virtues*. Originally designed around 1519 under the supervision of Raphael, and following cartoons by Giovanni da Udine (1487–1564), those tapestries no longer survive. A later edition of the series produced in Brussels around 1560 (fig. 3) was acquired by 1673 by the French king, Louis XIV (r. 1643–1715). At that time, the cartoons were thought to have been painted by Raphael himself.[11] The Gobelins copied the esteemed Brussels series beginning in 1688 after fresh cartoons prepared by Noël Coypel (1628–1707; fig. 4).[12] Though

the Gobelins project coincided with the creation of the Beauvais series, the two differed markedly in appearance and iconography.

Inventory records offer some description of the Beauvais series, particularly concerning the rather unusual deep-orange ground color and the quality of available weaves. For instance, an entry in the French royal inventory mentions a set of tapestries delivered by Béhagle in 1696 for the Château of Marly as "Grotesques with a wool ground of dead leaves, within a border of green gadroons." Similar language appears in the postmortem inventory of Charles Maurice Le Tellier (d. 1710), the archbishop of Reims. In the storeroom of his residence was a tapestry set of six pieces "representing grotesques, dead-leaf ground, Beauvais

production," woven with the arms of the owner.[13] Contemporaries, therefore, likened the prevailing deep-orange ground color of the tapestries to the golden-brown hue of autumnal leaves. This color palette was an extraordinary novelty: while yellow sometimes appeared as the ground color in Renaissance grotesque compositions, the warmer orange tone did not figure among the customary shades of red, green, and blue that commonly graced seventeenth-century French domestic interiors of the fashionable and wealthy.[14] In order to further expand the marketability of the series, the Beauvais manufactory executed tapestries in two grades of weave, one finer and more costly (priced at 80 to 100 livres per square ell), and the other less fine but more affordable (57 livres per square ell).[15]

SUBJECT AND MEANING

Curiously, documents of the period reveal little about the individual subjects portrayed in the Beauvais *Grotesques* tapestries. Nowhere were the scenes named. Nor was it necessary to buy all the available panels in order to display and appreciate the series. The Cronström-Tessin correspondence of January 1695 tells us that *Grotesques* sets could be

specially ordered without too much difficulty or delay. Moreover, upon request, existing tapestries in stock could be cut, without damage to the overall design, into two or three narrow sections, and their borders adjusted (fig. 5), in order to create separate hangings.[16] Only a few six-piece sets remain intact today, most notably those in Schloss Bruchsal near Karlsruhe (with a white-ground border of colorful grotesque ornament and chinoiserie figures; see fig. 16) and in the Musée des Tapisseries in Aix-en-Provence (with a border of green gadroons).[17] Also, figures from one panel could reappear in another hanging of the same set without lessening its overall aesthetic merits. Given the multiplicity of scenes and all the variant combinations produced, it wasn't until 1933 that researchers began to identify and apply provisional names to the six most commonly woven subjects: *The Offering to Bacchus* (see fig. 2), *The Offering to Pan* (see fig. 28), *The Camel* (see fig. 35), *Musicians and Dancers* (see fig. 48), *The Elephant* (see fig. 9), and *The Animal Tamers* (see fig. 16).[18]

The narrative meaning behind the Beauvais *Grotesques* has proven elusive. As yet, no one has identified with certainty the story line or libretto. Understanding has been hampered by

the absence of contemporary explanation, the seemingly disparate and unrelated subjects, and the perceived superficiality of the series as solely decorative. But the intermingling of the two mythological subjects with four others portraying divertissements points promisingly toward a unifying theme based in theater or spectacle. It is of no small significance that the two pagan gods portrayed, Bacchus and Pan, were considered protector deities of theater.[19] These gods were customarily linked to triumphs and festivities in seventeenth-century music and dance performances, as in the 1651 *Ballet of the Fetes of Bacchus*.[20] When they appeared with their fauns and nymphs, shepherds and bacchants, Bacchus and Pan often symbolized the mythical and idealized pastoral world of the harmonious Arcadian Golden Age. On stage, their entrances were typically accompanied by trumpet, transverse flute, musette, woodwinds, and percussion instruments. These instruments were associated with comedy as opposed to the rallying sounds of drums, which were considered better suited to heroic martial scenes.[21] The instruments visible in the *Grotesques* tapestries are clues that support this supposition.

The twentieth-century scholar Roger-Armand Weigert was first to

suggest credible links between the performing arts and the Beauvais *Grotesques* tapestries. Specifically, he posited that the 1675 restaging of *Carnaval Masquerade* had direct impact on their design.[22] Presented at the Royal Academy of Music in Paris, this ballet-masquerade was created by composer Jean-Baptiste Lully (1632–1687) and the playwrights Molière (born Jean-Baptiste Poquelin, 1622–1673) and Philippe Quinault (1635–1688) as a spectacle of French, Spanish, Italian, and Turkish divertissements that were chanted, sung, and danced in skits akin to our modern-day musical-comedy review. The acts included Basque dancers playing tambourines and castanets, performing Egyptians, guitar-playing Bohemians, Italian characters and musicians, and a scene involving a Turkish mufti excerpted from Molière's 1670 comedy-ballet *The Middle-Class Gentleman* (*Le Bourgeois Gentilhomme*). There is merit in Weigert's hypothesis: figures in at least two of the tapestries (*The Camel* and *Musicians and Dancers*) are attired in corresponding theatrical costumes and carry or play these instruments. But as not all the compositional elements of the tapestries can be traced to this single ballet-masquerade, the *Grotesques* likely portray a different

stage production or else a medley of scenes from court and public spectacles.

ARTISTS AND INFLUENCES

Who was the ingenious designer of the Beauvais *Grotesques* tapestries? According to Cronström's letter, it was "Baptiste, the excellent painter and ornamentalist." Sometimes styled "Baptiste," the artist Jean-Baptiste

Monnoyer was born in Lille in 1636 but soon moved to Antwerp, where he is said to have studied history painting before training with the still-life artist Jan Davidz. de Heem (1606–1683/84). After arriving in Paris as a teenager around 1650 or 1655, he attracted the notice of Charles Le Brun, who recruited him to work at the Hôtel Lambert and the Château of Vaux-le-Vicomte as well as at the

French royal residences of Vincennes, Saint-Cloud, Saint-Germain-en-Laye, Versailles, the Trianon, Meudon, and Marly and at the Menagerie of Versailles. He was received into the French Royal Academy of Painting and Sculpture in 1665, with a specialization in painting fruit and flowers. Elements from his reception piece, a still life, reappear later in the *Grotesques*, notably a sphinx reclining on

a stone balustrade, luxuriant drapery, festoons of flowers, and ornamental vases (fig. 6).[23]

From 1666 Monnoyer was also employed at the Gobelins, painting cartoons for *The Royal Residences/ Months of the Year* and *The Gallery of Apollo at the Château of Saint-Cloud* tapestry series. He later retouched the *Old Indies* tapestry cartoons. His tenure there overlapped with those of the talented animal painter Pieter Boel and the weaver Philippe Béhagle, who would in 1684 become the director of the Beauvais tapestry manufactory. As director, Béhagle hired Monnoyer to provide cartoons for the *Grotesques* and to assist with the strikingly original *The Story of the Emperor of China* series (ca. 1686–90), the latter in collaboration with fellow painters Guy-Louis Vernansal (1648–1729) and Jean-Baptiste Belin de Fontenay (1653–1715), Monnoyer's son-in-law.[24] While working under Le Brun, Monnoyer must have caught the eye of Ralph Montagu (1638?–1709), the English ambassador extraordinary to the court of Versailles from 1676 to 1677, for he later invited the artist to decorate Montagu House in London. Records indicate that Monnoyer was in England in 1690 (the year of Le Brun's death) and then again from 1692

until his own death in February 1699, active at Kensington Palace, Hampton Court Palace, and elsewhere with his son Antoine Monnoyer (1670–1747).

At face value, Monnoyer's biography does not adequately explain the depth of artistic wit buried in the Beauvais *Grotesques*. More research is needed to better reveal the development of his skill and intellect. That said, Monnoyer's position shouldn't be underestimated. Immersed in the circles of Le Brun (nominated in 1662 and confirmed in 1664 as first painter to the king), the French Royal Academy of Painting and Sculpture, and the French royal manufactory at the Gobelins, he had access to extensive collections and resources, the extent of which is yet to be fully understood.[25]

The Cronström-Tessin correspondence links the Beauvais *Grotesques* with another artist, Jean Bérain the Elder, who is credited with inventing a geometric border pattern for it: "a border in the grotesque taste from a design of Berain, of red broken rods against a blue ground."[26] While the letter doesn't elaborate beyond this summary statement, it is undeniable that Bérain's overall influence on the composition of the tapestries was of much greater import than was hinted by the envoy's report. His whimsical,

gravity-defying arabesques, sceno-graphic stage sets, and theatrical costumes were so fundamental to the conception of the series that historians from the mid-nineteenth century titled it the *Grotesques of Bérain*.[27] The pervasive and powerful force of this prolific draughtsman and ornamentalist flowed from his work, from 1674 to 1711, for the royal agency known as the Menus-Plaisirs, which was responsible for court ceremonies ranging from festivals to funerals, and, additionally, from his work as designer for the Paris Opera from 1680 (see fig. 38).[28] Monnoyer may have attended events staged under the artistic direction of Bérain, seen rehearsals, or heard of them indirectly from eyewitnesses. Moreover, Bérain's designs were widely disseminated in print form during his lifetime and were readily available to Monnoyer in this format (see fig. 32).[29] One last document, a Beauvais memorandum of 1731, lists a six-piece set woven in 1725 as "Another set of *Grotesques* design, with small Chinese figures, by Baptiste and Vernensal [sic]," valued at 6,764 livres.[30] Though ambiguously worded, this source seems to name the two artists responsible for the chinoiserie-style border of the tapestries as Jean-Baptiste Monnoyer and

Figure 7
Detail of Tapestry, *The Offering to Bacchus* from *The Grotesques* (figure 2)

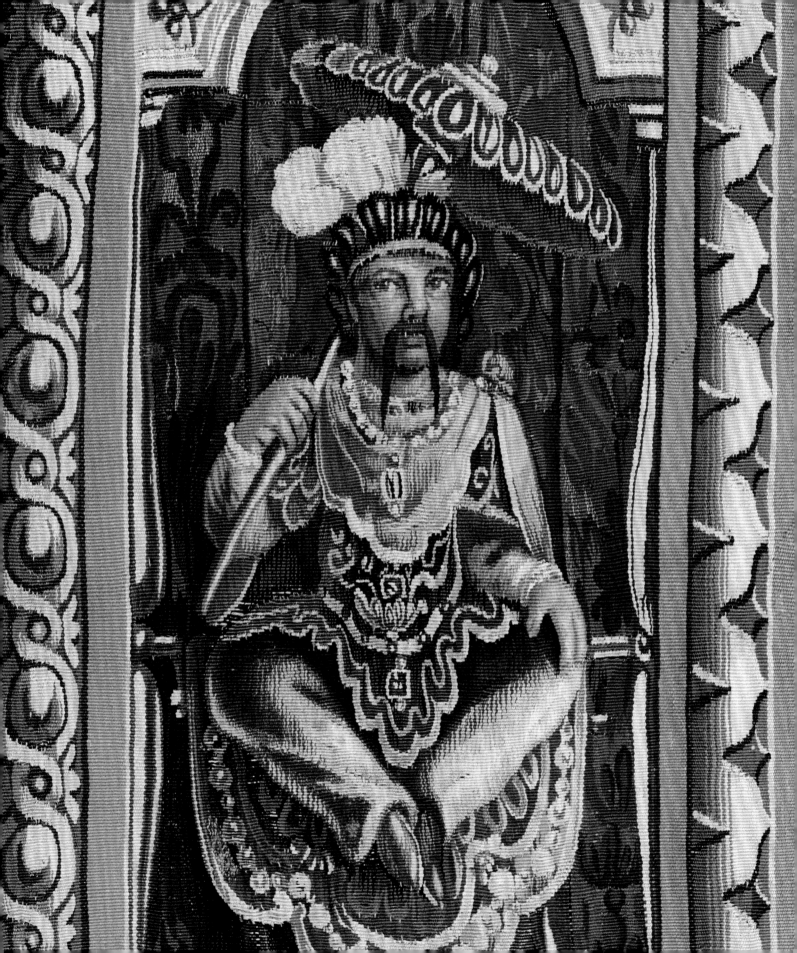

Guy-Louis Vernansal. This comparatively wide, white-ground border with colorful grotesque ornament and chinoiserie figures was the most detailed and complex border type available to Beauvais customers. It was applied to *Grotesques* tapestries from before 1705 and seems to have been popular, given the numerous examples that survive.[31] The authoritative, cross-legged figure positioned at the midpoint of the vertical stretches of the border (fig. 7) relates quite closely to the portrayal of the enthroned emperor in the contemporary Beauvais production of *The Story of the Emperor of China* (fig. 8), a series designed by Vernansal and for which Monnoyer assisted in painting the cartoons.

VISUAL PUZZLES

The panel known as *The Elephant* (fig. 9) offers a good opportunity to begin tracing the unexpected and surprising visual precedents assimilated and repurposed by Monnoyer for the *Grotesques* tapestries. The docile animal is shown in profile with one foreleg raised and its large, bejeweled ear curiously pierced with multiple rings. The creature seems a caricature of itself, young or small in scale (compared to its rider and mahout, or handler) and trained for performance,

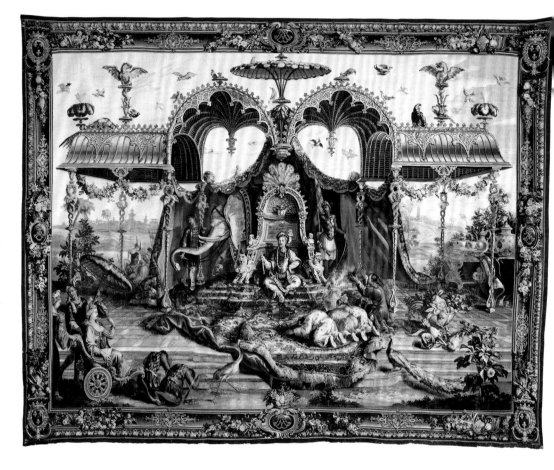

bearing all the trappings of a theatrical parade caparison with tassels and bell (fig. 10).

Ultimately, its pose and trappings were inspired not from life but from the line of elephants painted by Andrea Mantegna (ca. 1431–1506) in his monumental cycle *The Triumphs of Caesar* (fig. 11), a set of nine canvases he executed 1484–92 for the Gonzaga dukes of Mantua. After King Charles I of England (r. 1625–49) purchased the

Figure 8

Tapestry, *The Audience of the Emperor* from *The Story of the Emperor of China*, French (Beauvais manufactory), after the design by Guy-Louis Vernansal (French, 1648–1729), Jean-Baptiste Monnoyer (French, 1636–1699), and Jean-Baptiste Belin de Fontenay (French, 1653–1715), ca. 1697–1705. Wool and silk, 425 x 540 cm (167⅜ x 212½ in.). Musée National du Château de Compiègne, inv. C357C

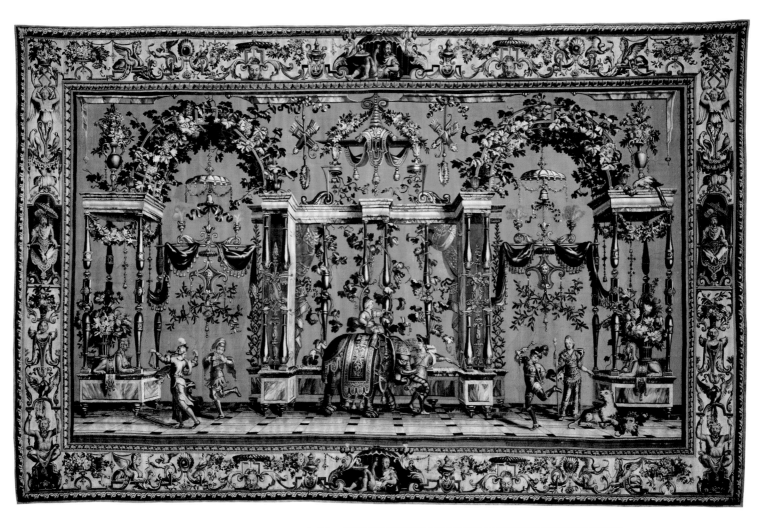

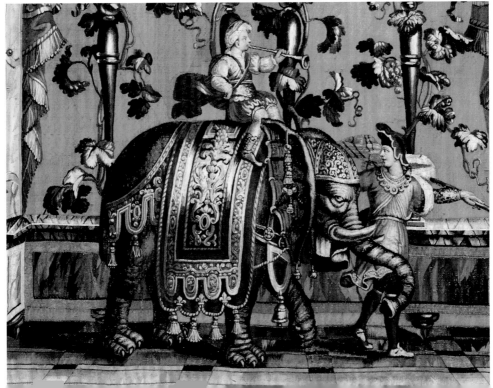

Figure 9
Tapestry, *The Elephant* from *The Grotesques*, French (Beauvais manufactory), after the design by Jean-Baptiste Monnoyer (French, 1636–1699), border after the design of Jean-Baptiste Monnoyer and Guy-Louis Vernansal (French, 1648–1729), ca. 1690–1711. Wool and silk, 294.6 x 459.7 cm (116 x 181 in.). New York, Metropolitan Museum of Art, 1977.437.3. Gift of John M. Schiff

Figure 10
Detail of Tapestry, *The Elephant*

cycle, the paintings were installed in Hampton Court Palace in 1630. Monnoyer would not have encountered the massive originals until his travels to England in the 1690s, so his inspiration for the elephant in the *Grotesques* must have been adapted, instead, from an intermediary print after Mantegna—perhaps the late sixteenth-century chiaroscuro woodcut print by Andrea Andreani (1558/59–1629) that reproduced all the ornamental details adorning Mantegna's elephant with clarity and accuracy (fig. 12). Monnoyer was not the first to adapt and incorporate Mantegna's elephant and rider into tapestry. He followed two famous earlier productions, both conceived for Parisian tapestry looms: the *Story of Queen Artemisia*, designed principally by Antoine Caron (1521–1599) and woven 1601–27 in the Louvre and Saint-Marcel workshops; and the *Story of Alexander*, designed by Le Brun and produced 1664–88 at the Gobelins.[32] Designs, cartoons, and tapestries for both (and prints of the latter) would have been readily accessible to Monnoyer (fig. 13). His visual citations of these precedents were subtle, but to those familiar with the artistic imagery, they communicated his knowledge and deft interpretation of the motif. His use

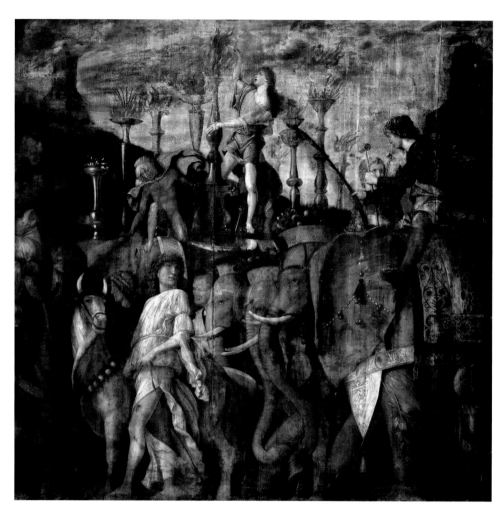

Figure 11
Andrea Mantegna (Italian, ca. 1431–1506), *The Elephants* from *The Triumphs of Caesar*, ca. 1484–92. Tempera on canvas, 270 x 280.7 x 4.0 cm (106¼ x 110½ x 1½ in.). Royal Collection Trust, Hampton Court Palace, RCIN 403962

Figure 12
Andrea Andreani (Italian, 1558/59–1629), after Andrea Mantegna (Italian, ca. 1431–1506), *The Elephants* from *The Triumph of Caesar*, 1599. Woodcut on paper, sheet: 40 x 39.7 cm (15¾ x 15⅝ in.). Los Angeles, Getty Research Institute, 88-F0

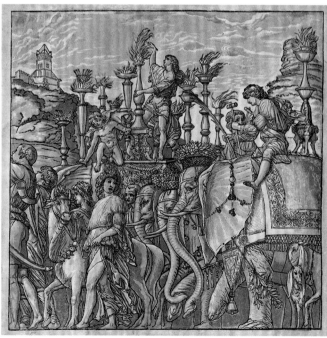

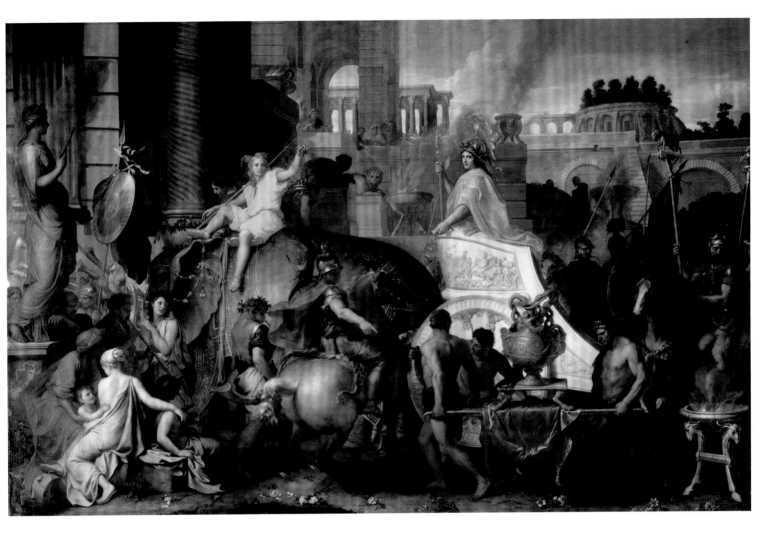

Figure 13
Charles Le Brun (French, 1619–1690), *The Triumph of Alexander*, 1665. Oil on canvas, 450 x 707 cm (177¼ x 278⅜ in). Paris, Musée du Louvre, inv. 2898

of the model differed from the two preceding tapestry cycles in that the Beauvais subject did not overtly refer to ancient history.

Over and above his fidelity to revered artistic sources, Monnoyer layered on new meaning garnered from the growing communal experience with exotic animals. Living elephants were among those creatures more and more frequently encountered in France in the second half of the seventeenth century. Until 1681 a tusked elephant lived in the Menagerie of Versailles, and afterward, its skeleton was on view at the

Royal Academy of Sciences in Paris. Additionally, Monnoyer's rendering of the animal in the tapestry reflected the influence of French court spectacle. His elephant shared a close affinity with one that had personified the continent of Africa in the May 1664 performance of *The Fete of the Pleasures of the Enchanted Island at Versailles* (fig. 14). In the act titled *The Seasons on Their Animals and Diana and Pan in the Laurel Branches*, actors dressed as the four seasons rode on animals symbolizing the four continents: spring on a horse representing Europe, summer on an elephant for

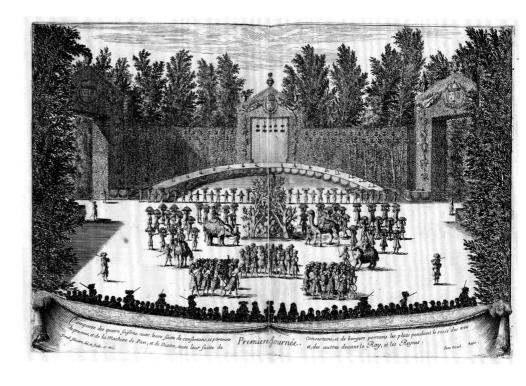

Africa, autumn on a camel for Asia, and winter on a bear for America.[33] Even if patrons of the Beauvais manufactory had not been present at the 1664 performance, the circulation of prints illustrating the event graphically perpetuated it (fig. 15). That collective memory, combined with new encounters with the exotic animal in menageries and traveling troupes, made the appearance of the elephant in the *Grotesques* all the more appealing.

The Animal Tamers was a less-frequently woven subject of the Beauvais *Grotesques* series (fig. 16).

Among the extant examples, even fewer included the ferocious combat in the lower left corner of the tapestry. Apparently, the pair of leopards attacking a bull constituted one of those optional lateral elements that most patrons elected to omit. Indeed, the implied violence of the scene hardly seemed in keeping with the general tone of the series, though it did hearken back to the days when the spectacle of animal combat and slaughter was a form of entertainment. To art cognoscenti and collectors of Renaissance and Baroque bronze statuettes, however,

Figure 14
After Henry Gissey (French, 1621–1673), *Sieur Du Parc Representing Summer, Riding an Elephant* from *The Seasons on Their Animals and Diana and Pan in the Laurel Branches*, 1664. Black chalk and graphite on paper, 53.6 x 38.2 cm (21⅛ x 15 in.). Stockholm, Nationalmuseum, NMH K 13:19 (Teatersamlingen)

Figure 15
Israël Silvestre (French, 1621–1691), *First Day: Supernumerary for the Four Seasons* from *The Pleasures of the Enchanted Island*, 1673. Etching and engraving, sheet: 41.6 x 50 cm (16⅜ x 19⅝ in.). Los Angeles, Getty Research Institute, 84-B21384

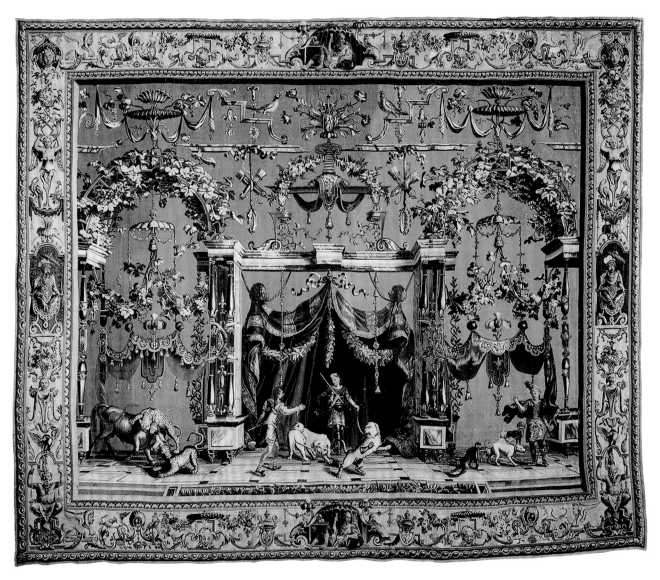

Figure 16

Tapestry, *The Animal Tamers* from *The Grotesques*, French (Beauvais manufactory), after the design by Jean-Baptiste Monnoyer (French, 1636–1699), border after the design of Jean-Baptiste Monnoyer and Guy-Louis Vernansal (French, 1648–1729), ca. 1688–1719. Wool and silk, 336 x 400.5 cm (132¼ x 157½ in.). Staatliche Schlösser und Gärten Baden-Württemberg, Schloss Bruchsal, inv. nr. G 102

Monnoyer's choice and pose of animals were particularly erudite, replicating not the more common group of a lion attacking a bull, after a prototype by the Italo-Flemish sculptor Giovanni Bologna (1529–1608), but rather the extremely rare version with a leopard (fig. 17). How Monnoyer came to copy the stance of this model remains a mystery as only two examples of the statuette are known now.[34] But the second, crouching leopard at the left and the crouching, growling lion with the shaggy mane at the center of this panel seem descended from the big cats portrayed in an ancient Roman wall mural that was reproduced as an engraving (fig. 18) in the album of Roman monuments titled the

Mirror of Rome's Magnificence (Speculum Romanae Magnificentiae), compiled during the sixteenth century by the Frenchman Antoine Lafréry (1512–1577) and others.[35]

It is necessary at this point to voice some cautionary concerns. As has been demonstrated, Monnoyer was so adept at assimilating his borrowed figures as to render them unrecognizable at first glance. He also adroitly and seamlessly combined elements from disparate and unexpected sources. The line between Monnoyer's borrowings and his own invention is blurred. The visual antecedents we have identified here are sometimes quite direct and at other times veiled, layered, or blended. While it is easy enough to find similarities of appearance or pose between elements of his design and other unrelated works of art, these similarities must remain classified as coincidental unless the probable lines of transmission can be traced. Deeper analysis is needed to fully and confidently map the visual, literary, and ephemeral sources available to Monnoyer and to accurately identify the thematic program of the *Grotesques* tapestries. Until then, this highly successful and popular series presents a conundrum that delights the eye and engages the mind.

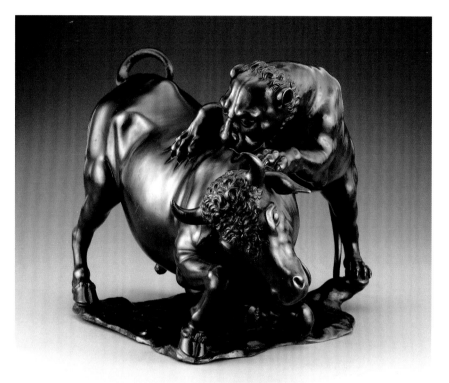

Figure 17

Giovanni Francesco Susini (Italian, 1585–1653), *A Leopard Attacking a Bull*, ca. 1630–40. Bronze, 11.9 x 27.5 cm (4 11/16 x 10 13/16 in.). New York, Frick Collection, 2002.2.03. Gift of Walter A. and Vera Eberstadt

Figure 18

Wild Animals, from *Antique Wall Paintings Discovered 1547, Plate 1* in Antoine Lafréry (French, 1512–1577), *Mirror of Rome's Magnificence (Speculum Romanae Magnificentiae;* Rome, 1544?–1602). Etching, sheet: 38.5 x 51.7 cm (15 1/8 x 20 3/8 in.). Los Angeles, Getty Research Institute, 91-F104

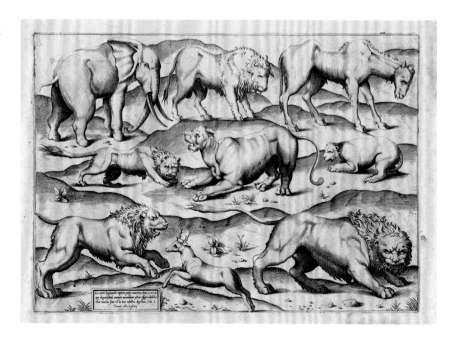

NOTES

Note: All translations are by the present author unless otherwise noted.

1. Furetière, *Dictionnaire universel*, 2:210–11.

2. Félibien, *Entretiens*, 2:242–43. Félibien wrote this passage in a short biographical statement about Giovanni da Udine (1487–1564), who was a pupil of and assistant to the painter Raphael (1483–1520). The Palace of Titus was a late first-century AD imperial structure on the Palatine Hill in Rome, very near the site of the Domus Aurea, or Golden House, of the Emperor Nero (r. 54–68). The palace's bathing chambers, decorated with grotesque-style frescoes, are thought to incorporate part of the preexisting Domus Aurea complex.

3. Badin, *Manufacture de tapisseries de Beauvais*, 11–13, 18, 21, 56; Standen, "Berain Grotesques," 2:441–58; Bremer-David, "Grotesques: L'Offrande à Bacchus," 72–79.

4. Iacopi, *Domus Aurea*.

5. Félibien, *Entretiens*, 2:242–43.

6. Cowart, *Triumph of Pleasure*, xv–xvii, 21, 84–89. On the commedia dell'arte in Paris, see V. Scott, *Commedia dell'Arte in Paris*.

7. A few late seventeenth-century tapestry cartoons survive, but not those for the Beauvais *Grotesques*. Thus, the weavings themselves are our only evidence of their original tonality—a tonality best appreciated by viewing the unfaded backs of the tapestries that have been protected from exposure to light.

8. Adelson, "The Camel," 307–21; and Pazzis-Chevalier, *Quand grotesque*, 10–11.

9. Grouchy, "Notes sur les tapisseries," 62–64.

10. Weigert and Hernmarck, *Cronström correspondance*, 64–65.

11. The set was acquired from two different sources, as the component pieces had been separated. Four hangings came from the Polish royal household. A Polish royal inventory of 1648 recorded those as "Crotesques. Dessein de Raphaël." Campbell, "Designs for the Papacy," 225–29. Three other pieces came from the estate of a French nobleman, Bernard de Nogaret de La Valette, duc d'Épernon (1592–1661). Bremer-David, "Triumphs of the Gods."

12. Forti Grazzini, "Triumph of Venus," 397–405. For the Gobelins edition of the tapestry series, French artists living in Rome prepared a cartoon for the eighth subject missing from the French set, *Grammar among the Liberal Arts*. The artists followed the original papal tapestry still in the Vatican. Concerning an extant cartoon of 1693 by Noël Coypel for the Gobelins production of *The Triumphs of the Gods*, see Salmon, *Triomphe de Vénus*.

13. Guiffrey, *Inventaire général*, 1:362–63; and Weigert, "Inventaire des tapisseries," 24.

14. Pardailhé-Galabrun, *Birth of Intimacy*, 170–73.

15. An ell was a unit of linear measure equivalent to approximately 69.75 cm, or nearly 27½ inches. For a contemporary cost comparison, the French crown reimbursed the director of the Beauvais manufactory thirty livres for the annual cost of feeding and lodging each apprentice. The names of the earliest purchasers of the *Grotesques* series and the two grades of prices were listed in an undated memorandum, probably written before 1695, by Béhagle, "Estat du produit de quelques marchandises fabriquées dans la manufacture royale de tapisseryes de Beauvais," reproduced in Badin, *Manufacture de tapisseries de Beauvais*, 12–13. For further identification of these buyers and for an explanation concerning the linear unit of an ell, known as an aune at the Beauvais manufacture, see Bremer-David, "Manufacture Royale de Tapisseries de Beauvais," 409, 419n11, and "The Camel," 427–33.

16. Weigert and Hernmarck, *Cronström correspondance*, 64.

17. Stratmann-Döhler, "Groteskenfolge," 55–62; and Weigert, *Décor Berain*, entries 2–7. No sets of more than six pieces survive intact, though several five-piece sets do, notably those in the Metropolitan Museum of Art, New York (with a white-ground border of colorful grotesque ornament and chinoiserie figures) and in the City Hall, Stockholm (with a border of green gadroons). See Standen, "Berain Grotesques"; Stockholm360.net, "The Oval (City Hall) Stockholm, Sweden," virtual tour, accessed December 30, 2013, http://www.stockholm360.net/fp.php?id=ch-ovalen2. Regrettably, an eight-piece set was dispersed in the first half of the twentieth century. Standen "Berain Grotesques," 443, 454n17.

18. Weigert, "Grotesques de Beauvais et les tapisseries de Chevening (Kent)," 7–21.

19. Blunt, *Poussin*, 135–41; and Wine, "Triumph of Pan" 353, 362n27. Blunt explains why some literary and visual presentations of *The Triumph of Bacchus* included exotic animals such as elephants and camels.

20. The 1651 *Ballet of the Fetes of Bacchus* incorporated burlesque revelry and *crotesque* music, as discussed in Cowart, *Triumph of Pleasure*, 18–33.

21. On the evolution of instruments such as the violin, guitar, musette, and transverse flute in seventeenth-century France, see the entries by Dobney, "Violin, 'The Francesca,'" "Guitar," "Musette de cour," "Oboe," and "Transverse Flute" in Baetjer, *Watteau, Music, and Theater*, 132–39.

22. Weigert, "Grotesques de Beauvais et Les Tapisseries de Chevening (Kent)," 12. The 1675 entertainment was actually a restaging of an earlier court ballet, *Carnaval, royal masquerade*, composed by Lully and first performed at the Louvre Palace in 1668 with Louis XIV as a dancer. See Cowart, *Triumph of Pleasure*, 163–64, 174; Lully, *Carnaval, mascarade* and *Carnaval, mascarade royale*.

23. Salvi, *D'après nature*, 183–93. The reception piece is now in the Musée Fabre, Montpellier, inventory number D803-1-13.

24. Bremer-David, "Six Tapestries," 80–97, and "The Emperor Sailing," 272–77.

25. An inventory compiled on behalf of Jean-Baptiste Monnoyer's widow counted sixty-four books in the couple's Parisian residence on the rue Saint Antoine in March 1699. The document survives in the Archives nationales, Paris, Minutier central des notaires, MC/ET/XVI/613. Information courtesy of Maxime Georges Métraux, Paris.

26. Weigert and Hernmarck, *Cronström correspondance*, 77.

27. Weigert, "Grotesques de Beauvais," 66–73, 69.

28. Weigert, *Jean I Berain*; and La Gorce, *Berain*.

29. Bérain, *L'oeuvre de Bérain*, 12.

30. "État des tapisseries dont la manufacture de Beauvais est charge...," as reproduced in Badin, *Manufacture de tapisseries de Beauvais*, 21.

31. Borders of this type survive on tapestries bearing the woven name of *Behagle*, for Philippe Béhagle, director of the Beauvais manufactory from 1684 to his death in 1705. Standen, *Beauvais Grotesques*.

32. Brejon de Lavergnée and Vittet, *Tenture d'Artémise*; Vittet, *L'histoire d'Alexandre le Grand*; Bremer-David, "The Elephant," 263–67.

33. V. Scott, *Molière: A Theatrical Life*, 145–53.

34. The model for the bronze statuette of the leopard attacking a bull is now attributed Giovanni Francesco Susini (1585–1653) and dated to about 1630–40. Baumstark and Schneider, *Bronzen der Fürstlichen Sammlung Liechtenstein*, 177–79. See also Frick, "Major Gift."

35. Lafréry et al., *Speculum Romanae Magnificentiae*, unnumbered plate.

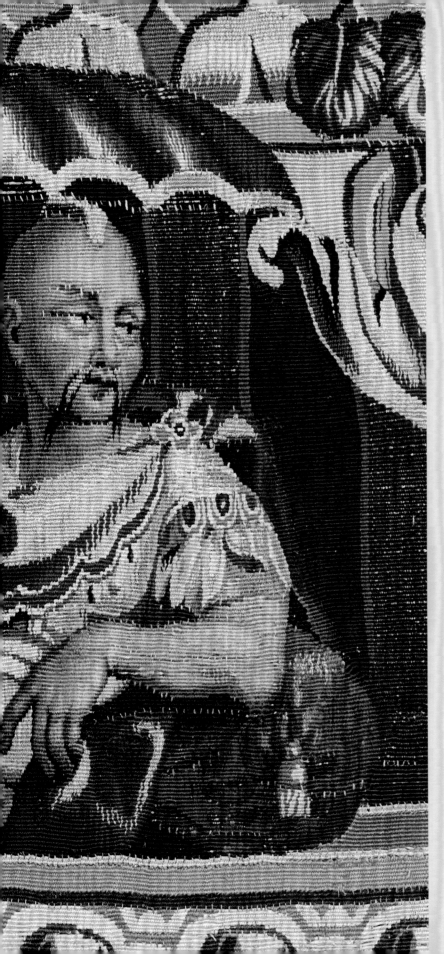

Detail of Tapestry, *The Offering to Bacchus* from *The Grotesques* (figure 2)

The Offering to Bacchus

The Offering to Bacchus presents a raised terrace on which stands a pergola with a low, segmented plinth wall and an architrave of colorfully veined marble, twelve spindly baluster columns, and a lattice dome (see fig. 2). Lattices entwined with blooming jasmine vines also front the raised terrace, while opposing rows of steps lead up to its stone-tiled floor. Grape vines with clusters of fruit climb either side of the pergola and its dome. A broad expanse of patterned orange-and-red cloth hangs from the curved architrave like a baldachin to shield a stone statue of Bacchus, ancient god of wine. The statue stands upon a black-and-white marble pedestal, one hand uplifted to hold a thyrsus—the staff with a pinecone finial used in bacchic rites—and the other resting upon a vine-encircled tree stump. A stylized

leopard crouches behind the deity. A red ribbon suspends a short shepherd's crook and a syrinx, or set of reed pipes, from the dome—though these implements are usually associated with Pan, god of shepherds and pastures. A supplicant stoops to place a vase of flowers just outside the sanctuary while a musician leans against the plinth wall and plays a straight trumpet.

The border of this tapestry (and the others that are the focus of this book) is wide, containing figures, vases, and birds interspersed amidst geometric straps, all set against a white ground. The horizontal stretches at the top and bottom echo each other, as do the vertical stretches at the left and right. The central point of each length is punctuated by a cartouche in which a figure reclines or sits: above and below, a warrior dressed in the soldier's gear of a cuirass and pteruges takes refreshment;[1] left and right, a potentate, his ankles crossed, holds a parasol (see fig. 7). The warrior's Mohawk hair style and the potentate's long, droopy mustache introduce an incongruous air of exoticism to the otherwise classical vocabulary of elements: satyrs with reed pipes, female caryatids, winged heads in fools' caps, baskets of fruit, smoking sensors, peacocks, parrots,

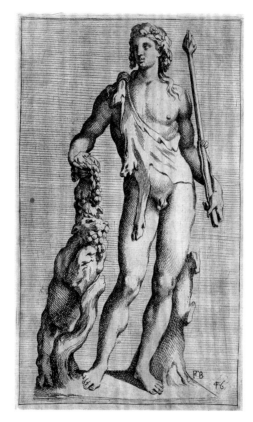

Figure 19
Lyæus Bacchus; Borghese Residence in François Perrier (French, 1594–1649), *Antique Statues of Rome (Segmenta nobilium signorum e[t] statu[arum]*; Rome, 1638), plate 46. Engraving, sheet: 34 x 23 cm (13 3/8 x 9 in.). Los Angeles, Getty Research Institute, 82-B2130

Figure 20
Detail of Tapestry, *The Offering to Bacchus* from *The Grotesques* (figure 2)

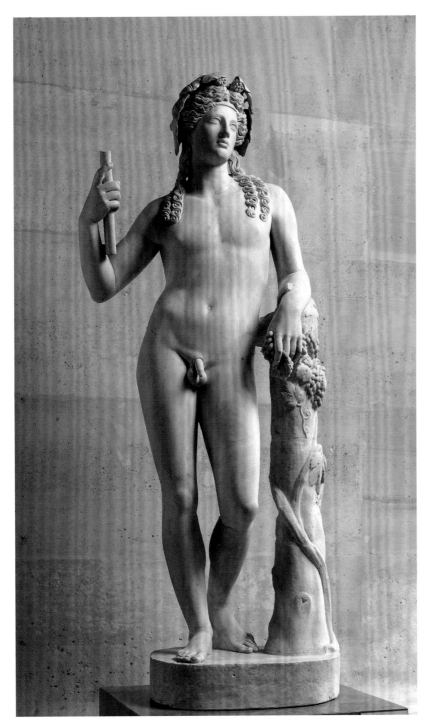

Figure 21
Bacchus, Roman, 2nd century, with later restorations. Marble, H: 208 cm (81⅞ in.). Paris, Musée du Louvre, inv. MR 107 (MA 87)

birds, floral garlands, swags of jewels, acanthus-leaf scrolls, and straps.[2] The longer horizontal stretches of this border, when applied to wider weavings, feature additional motifs: satyrs' masks, female torsos, squirrels, and a wading bird whose beak pinches a sinuous snake before a winged sphinx (see figs. 35 and 48).[3]

VISUAL SOURCES

The statue of Bacchus—with its goatskin drapery, contrapposto pose, short thyrsus, vine-encased tree stump, and crouching leopard—was probably a conflation of two well-known antique marbles. The first was the full-figure sculpture of Bacchus in the collection of the Borghese family, which Monnoyer could have known indirectly by the drawing (fig. 19) reproduced graphically in the widely disseminated 1638 anthology of the most admired antique sculptures in Rome, *Antique Statues of Rome (Segmenta nobilium signorum e[t] statu[arum])* by François Perrier (1594–1649).[4] However, comparing this source with the Bacchus in the tapestry (fig. 20) reveals distinct differences. For example, the position of the god's limbs and attributes in the tapestry suggests that Monnoyer did not rely on the Perrier print alone. It seems he incorporated certain

compositional features—especially the left arm leaning on a vine-encased tree stump and the raised right hand grasping the thyrsus—from another ancient Roman marble of Bacchus (fig. 21). This work was from the collection of Cardinal de Richelieu (born Armand Jean du Plessis, 1585–1642), which Monnoyer may have seen in person, either in the cardinal's château in Poitou or, after its removal, in the Paris residence of his heirs.[5]

The trumpeter in the tapestry echoed yet another antique marble, *The Faun Playing the Flute*, that was also in the Borghese collection in the seventeenth century and illustrated by Perrier in his *Antique Statues of Rome* (fig. 22).[6] By the 1680s it was one of the most admired works of antiquity and was often the subject of casts and copies. For instance, Simon Hurtrelle (1648–1724) copied it in 1685 at the request of Louis XIV for the parterre of Latona at Versailles (fig. 23). But to obfuscate this overt influence, Monnoyer cleverly disguised his version in an elaborate costume, altered the contrapposto sway of the trumpeter's hips and leg positions, and changed the instrument (fig. 24).

The crouching supplicant (fig. 25) may ultimately derive from the kneeling maid with the water jug portrayed in the 1648 painting *Eliezer*

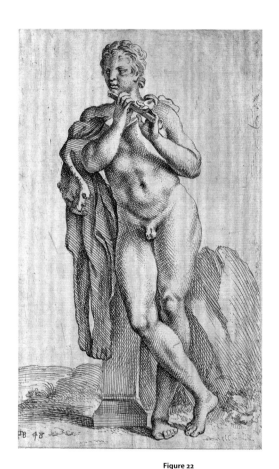

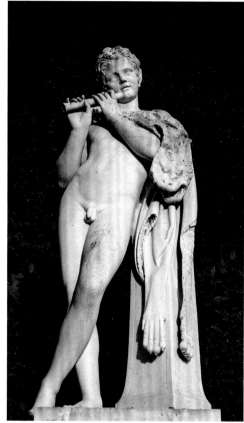

Figure 22
Faun with Pipe; Borghese Gardens in François Perrier (French, 1594–1649), *Antique Statues of Rome* (*Segmenta nobilium signorum e[t] statu[arum]*; Rome, 1638), plate 48. Engraving, 34 x 23 cm (13⅜ x 9 in.). Los Angeles, Getty Research Institute, 82-B2130

Figure 23
Simon Hurtrelle (French, 1648–1724), *Faun Playing the Flute*, 1685. Marble, H: 230 cm (90½ in.). Château de Versailles, Parterre of Latona, North Ramp, inv. 1850 no. 9096

Figure 24
Detail of Tapestry, *The Offering to Bacchus* from *The Grotesques* (figure 2)

and Rebecca executed by Poussin for the Paris-based banker and merchant Jean Pointel (fl. 1640–after 1665). Once it passed to Louis XIV in 1665 and entered the King's Cabinet, the work became renowned in the artistic community.[7] It was the focus of a lecture by Philippe de Champaigne (1602–1674) that he addressed to the French Royal Academy of Painting and Sculpture in January 1668. As a member of the prestigious academy since 1665, Monnoyer would likely have attended the lecture and, moreover, would have known of the painting's reproduction as a 1677 engraving by Gilles Rousselet (1610–1686; fig. 26). But the female in the tapestry differed from Poussin's model, and there were, of course, other possible prototypes. The crouching position of the woven figure and her basket correspond to details in an engraving of about 1532 titled *A Sacrifice to Priapus* (fig. 27) by the Master of the Die (active ca. 1532), reputedly after a lost design of Giulio Romano (probably 1499–1546), the revered pupil of Raphael. It seems Monnoyer also consulted this image for another tapestry in the series, *The Offering to Pan* (Tapestry 2).

Figure 25
Detail of Tapestry, *The Offering to Bacchus* from *The Grotesques* (figure 2)

Figure 26
Gilles Rousselet (French, 1610–1686), after Nicolas Poussin (French, 1594–1665), *Eliezer and Rebekah*, 1677. Engraving, image: 42.3 x 63 cm (16⅝ x 24¾ in.), sheet: 63.4 x 87.5 cm (25 x 34½ in.). Los Angeles, Getty Research Institute, 2001 PR 3 34

Figure 27
Master of the Die (Italian or German, active ca. 1532), after Giulio Romano (Italian, probably 1499–1546), *A Sacrifice to Priapus*, ca. 1532 (second state impression 1530–60). Engraving on paper, 15.8 x 28.6 cm (6¼ x 11¼ in.). London, British Museum, 1873,1213.255

NOTES

1. A cuirass is a form-fitting armor corset. Pteruges are the leather or cloth strips suspended from the waistband of a soldier's skirt. The reclining pose of this warrior, with one hand holding a cup and the other arm bent at the elbow, echoes that of a reclining male painted in the frescoed vault of the Achilles Room in the Domus Aurea. See Iacopi, *Domus Aurea*, 66.

2. The satyr with arms upraised was inspired by the half-figured model in a vertical border of the famed *Acts of the Apostles* tapestry series designed by Raphael in 1516 for Pope Leo X. Müntz, *Tapisseries de Raphaël*, 29–33.

3. The motif of the bird with the snake is not dissimilar to the stork with the serpent in the roundel illustrating some title pages of Félibien's multivolume *Entretiens*. Since antiquity, the stork was esteemed for its habit of eating serpents, by which it rendered a service to humans. Pliny the Elder recounted how it was a capital crime in Thessaly to kill a stork for this reason; see Pliny the Elder, *Natural History*, bk. 10, chap. 31. Emblematic books since the Renaissance have often portrayed the stork with a serpent in its beak, notably Alciati, *Emblemata*, 142.

4. Perrier, *Segmenta nobilium*, plate 46. Dated to about 100–150, the Roman sculpture remains today in the Galleria Borghese, Rome, inventory number 143. Scuola Normale Superiore di Pisa, "The Reception of Antique Statuary," accessed September 11, 2013, http://mora.sns.it/_portale/.

5. This Bacchus, also a second-century Roman sculpture, entered the musée du Louvre in 1797, where it remains, inventory MR 107 (MA 87). Musée du Louvre, *Atlas* database, accessed May 14, 2015, http://cartelen.louvre.fr. Other variants and fragments of the model may have been known to Monnoyer. See Maral and Milovanovic, *Versailles et l'antique*, 12, 48.

6. Perrier, *Segmenta nobilium*, plate 48. The Roman sculpture is today in the musée du Louvre, inventory MR 187 (MA 594); its date of origin is disputed. Musée du Louvre, *Atlas* database, accessed May 14, 2015, http://cartelen.louvre.fr. Haskell and Penny, *Taste and the Antique*, 212–13.

7. The painting is now in the musée du Louvre, inventory 7270. Louvre, *Notices* database, accessed October 6, 2014, http://www.louvre.fr/en/oeuvre-notices/eliezer-and-rebecca/. Verdi, *Poussin*, 261–63.

TAPESTRY 2

The Offering to Pan

The scene of *The Offering to Pan* takes place under a marble entablature draped with a pair of red-and-gold curtains (fig. 28). The stone pedestals of the balustrade support six metallic tubs, each containing a small leafy tree bearing white blossoms and red fruit. The scene centers around a stone herm of Pan, ancient god of shepherds and pastures, whose head is crowned with a carven wreath of grape leaves. The deity is attended by three bacchantes, one of whom drapes the herm with a garland of flowers. She balances unsteadily, with her left foot planted on the tiled floor of the terrace and her right knee bent on the back of a goat, while her arms stretch out in a diagonal line extending from the shoulder of the herm to a basket held up by a young page to the left. The two other attendants tap tambourines

Detail of Tapestry, *The Offering to Pan* from *The Grotesques* (figure 28)

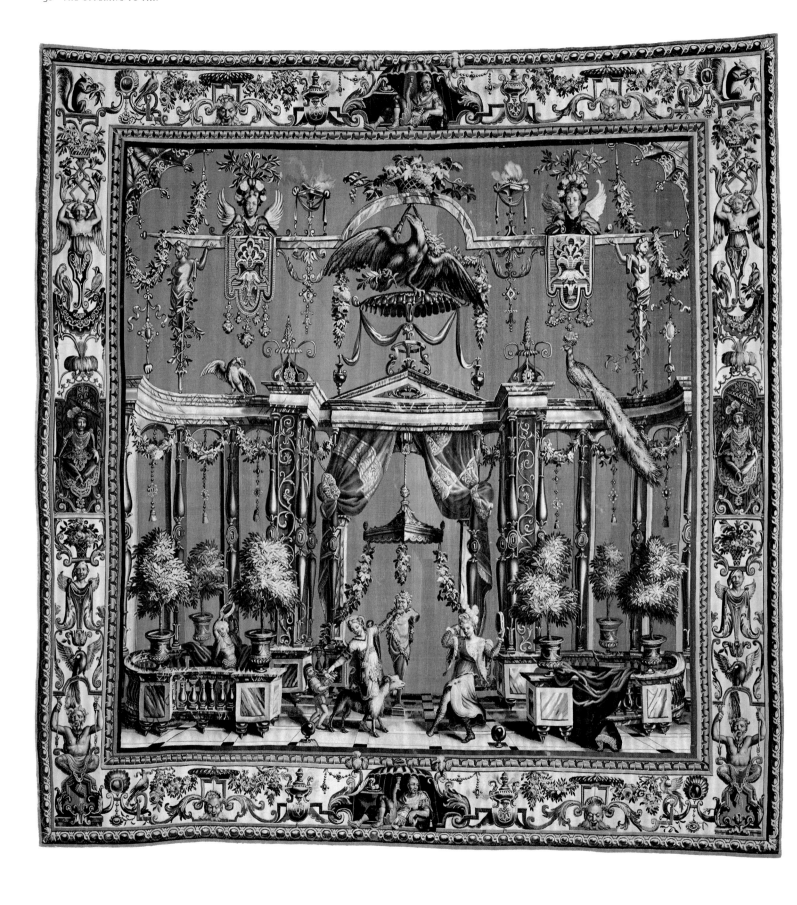

Figure 28
Tapestry, *The Offering to Pan* from *The Grotesques*, French (Beauvais manufactory), after the design by Jean-Baptiste Monnoyer (French, 1636–1699), border after the design of Jean-Baptiste Monnoyer and Guy-Louis Vernansal (French, 1648–1729), ca. 1690–1730. Wool and silk, modern cotton lining, 322.6 x 302.3 cm (127 x 119 in.). Los Angeles, J. Paul Getty Museum, 2003.2

Figure 29
Detail of Tapestry, *The Offering to Pan* from *The Grotesques* (figure 28)

Figure 30
Nicolas Poussin (French, 1594–1665), *The Triumph of Pan*, 1636. Oil on canvas, 135.9 x 146 cm (53½ x 57½ in.). London, National Gallery, NG6477

and dance (fig. 29). A peacock and a pheasant perch on the architrave, while upon a small, ribbed canopy above the pediment stands an eagle, its wings spread open and one talon grasping a green-leafed branch.

VISUAL SOURCES

The herm, three of four attendant figures, and even the goat were derived from a painting by Nicolas Poussin, *The Triumph of Pan* (fig. 30).[1] Poussin executed the commission in Rome in 1636 for Cardinal de Richelieu and dispatched it, together with another work titled *The Triumph of Bacchus*, to the cardinal's château in Poitou. As surprising as this connection may appear to modern eyes, the visual transmission of subject and form was possible within the flourishing artistic milieu of Paris in the 1680s. Thanks to the art chronicler and historian André Félibien (1619–1695), Poussin's pictures in the Richelieu collection were known and celebrated by means of his widely circulated 1685 volume of *Discussions concerning the Lives and Works of the Most Excellent Painters, Ancient and Modern*.[2] Monnoyer would surely have been familiar with the writings of Fébilien, especially given their shared experiences of attending lectures at the French Royal Academy of Painting

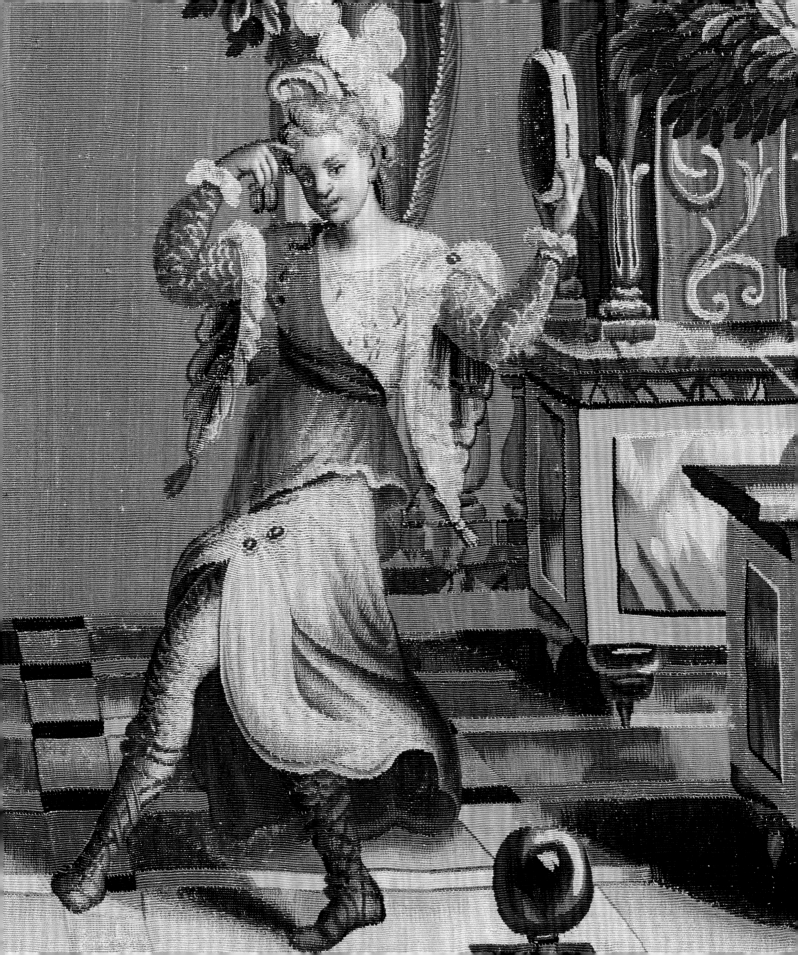

Figure 31
Detail of Tapestry, *The Offering to Pan* from *The Grotesques* (figure 28)

Figure 32
Jean Bérain the Elder (French, 1640–1711), *Season of Winter with the Zodiacal Signs of Capricorn, Aquarius, and Pisces,* before 1693. Engraving, sheet: 51 x 36.5 cm (20⅟₁₆ x 14⅜ in.). Los Angeles Getty Research Institute, 87-B11137

and Sculpture. But, like Gian Lorenzo Bernini (1598–1680), Monnoyer may well have seen the copy of Poussin's *Triumph of Pan* owned by the art collector Paul Fréart de Chantelou (1609–1694) in Paris. In any case, Monnoyer did not simply reproduce the figures, as they were only partially visible in Poussin's composition. Rather, he invented the lower portions of their bodies and then disguised their forms in very different, more modest and theatrical, attire. It is also plausible that, like Poussin, Monnoyer could have consulted an earlier print on the theme showing a herm of Priapus, god of gardens and fertility (see fig. 27). The engraving was executed about 1532 by the Master of the Die and reputedly followed a lost design of Giulio Romano.[3] Indeed, the tapering pedestal of the herm in the tapestry is closer to the engraving than to Poussin's rendering. In this double reference—to the painting by Poussin and the print after Romano—Monnoyer was exhibiting his own awareness of not only a celebrated contemporary model but also its obscure Renaissance source.

The largest attendant in the tapestry, the only one shown in full figure, is the dancing bacchante to the right of the herm (fig. 31). This bacchante has been likened to another model

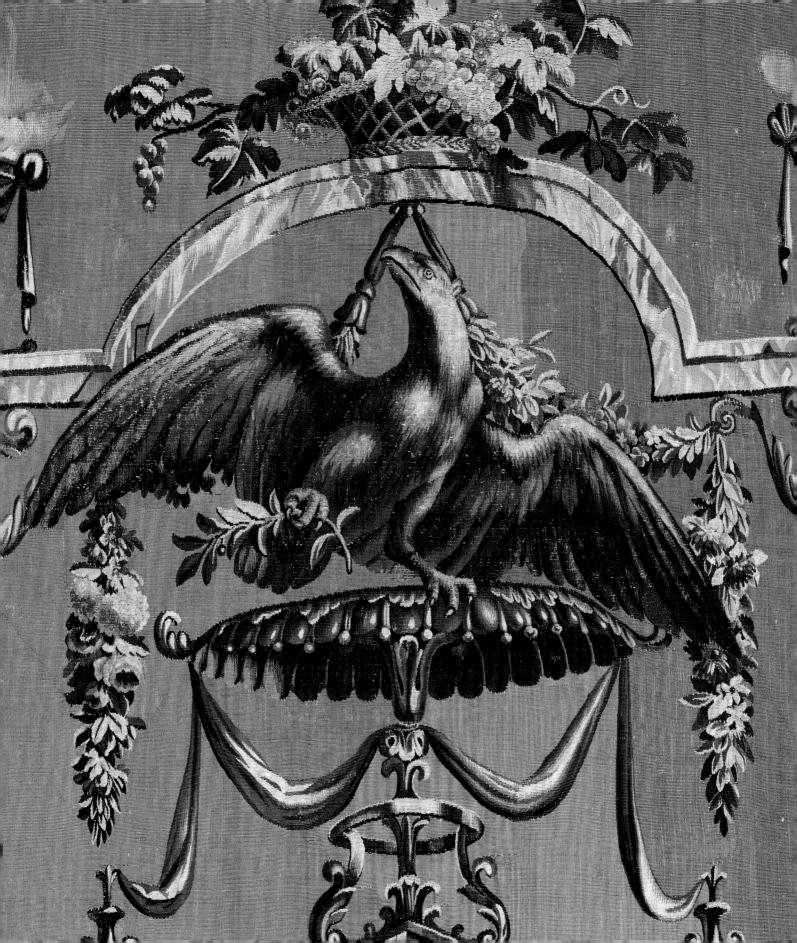

from Poussin—that of Flora from his 1631 painting *Kingdom of Flora*—but, if so, the means of its visual transmission to Monnoyer has not yet been traced.[4] If Poussin was the source of inspiration, Monnoyer once again modified the position of the model, as the woven figure's arms and costume have a closer affinity to the dancing tambourine player in the emblematic print of *Season of Winter with the Zodiacal Signs of Capricorn, Aquarius, and Pisces* (fig. 32) executed by Jean Bérain the Elder before 1693.

We can find the prototype of the prominent, open-winged eagle that appears in the upper register of taller versions of *The Offering to Pan* (fig. 33) in the study of two eagles by Pieter Boel—down to the splay of the talons (fig. 34). Like Monnoyer, Boel hailed from Antwerp, and he, too, found employment in the artistic circles of Paris and Versailles, becoming "painter ordinary to the king," with a specialization in animal subjects, in 1668.[5] From 1668 to 1674, their careers actually overlapped in Paris, painting tapestry cartoons for the French royal manufactory at the Gobelins, so each was intimately familiar with the work of the other. On several other occasions, Monnoyer used the studies of Boel as source material for the *Grotesques* tapestries (see Tapestries 3 and 4).

Figure 33
Detail of Tapestry, *The Offering to Pan* from *The Grotesques* (figure 28)

Figure 34
Pieter Boel (Flemish, 1622–1674), *Double Study of Eagles*, before 1674. Oil on canvas. 78 x 94.5 cm (30¾ x 37¼ in.). Paris, Musée du Louvre, inv. 3964

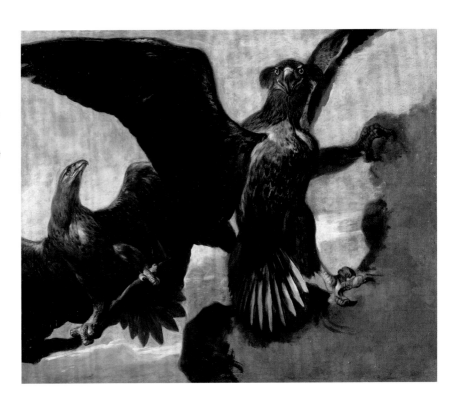

NOTES

1. A. Bennett, *Five Centuries of Tapestry* (1976), 224–27, and *Five Centuries of Tapestry* (1992), 258–61.

2. Félibien, *Entretiens*, 4:265.

3. Wine, "Triumph of Pan." Poussin's companion picture, *The Triumph of Bacchus*, is probably the version in the Nelson-Atkins Museum of Art, Kansas City, accession number 31-94.

4. A. Bennett, *Five Centuries of Tapestry* (1976). Poussin's *Kingdom of Flora* was commissioned by the Sicilian nobleman Fabrizio Valguarnera (fl. 1630s) and remained in Italy until 1715, when it passed into the collection of the electors of Saxony; it is now housed in the Staatliche Kunstsammlungen Dresden, Gemäldegalerie Alte Meister, inventory number 719. Verdi, *Poussin*, 180–81. In the 1992 edition of *Five Centuries of Tapestry*, Bennett apparently discounted this idea and did not mention it again. Other models of tambourine playing and dancing bacchantes were in circulation at the time. In the mid-1680s, for instance, Monnoyer himself painted a close variant in the tapestry cartoon *Spring*, part of a series woven at the Gobelins after the famous ceiling decoration of Pierre Mignard (1612–1695) for the Gallery of Apollo at the Château of Saint-Cloud. Vittet, "Example d'un ameublement," 126–31.

5. Foucart-Walter, *Pieter Boel*, 80–81.

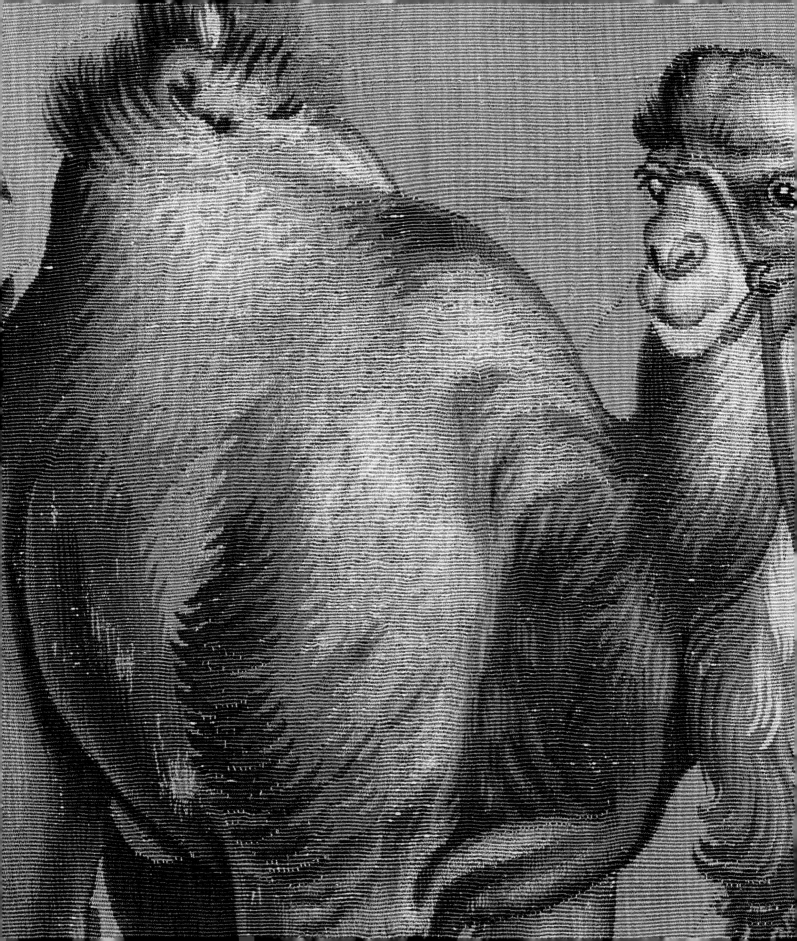

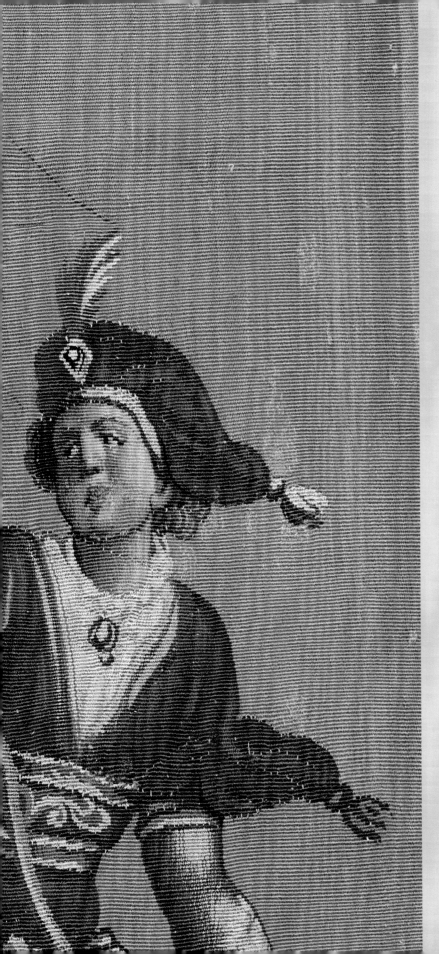

TAPESTRY 3

The Camel

The Camel portrays three theatrical divertissements under a tripartite arcade set upon a stone-tiled floor (fig. 35). The arcade is composed of a low, segmented plinth; spindly baluster columns and pilasters; a discontinuous architrave; and two lattice arches. Circular canopies with red curtains embroidered with gold trim hang from each arch. Parrots and a cockatiel perch on each. An articulated inner frame lines the pilasters and architrave of the central section, creating a cartouche-shaped space that is filled with a large, lush bouquet of flowers in full bloom. A pair of smaller baskets of flowers flank the far baluster columns. Leafy grape vines and clusters of fruit grow among the lattice frames of the arches. Acrobats, musicians, actors, and exotic animals perform. From left to right, the three acts consist of

Detail of Tapestry, *The Camel* from *The Grotesques* (figure 35)

a tightrope walker, a seated violinist, and a dancing jester who beats a tambourine; a masked commedia dell'arte actor, a large peacock, and two child aerial acrobats, one fitted with butterfly wings; and a camel with its handler, a leopard guarding bunches of grapes, and a child—or perhaps a dwarf—restraining a snarling lion. The upper fields of this tapestry and *Musicians and Dancers* (Tapestry 4; see fig. 48) are filled with ornament hanging from and rising above a horizontal molding: trophies of crossed quivers above a wreath, floral garlands and foliate cusps, trailing grape vines, ribbed canopies, narrow lengths of blue drapery, jewel clasps, birds, and cartouche shields.

VISUAL SOURCES

Some of the acts and performers portrayed in this tapestry visualize the pastiche and improvised nature of mid- to late seventeenth-century commedia dell'arte and urban street-fair entertainment, especially the tightrope walker at left, the aerial gymnasts at center, and the gesturing figure to the right of the large bouquet of flowers (fig. 36).[1] Presiding as master of ceremonies, this masked figure wears the traditional costume of Flautin, the stock character from the commedia dell'arte named for the small

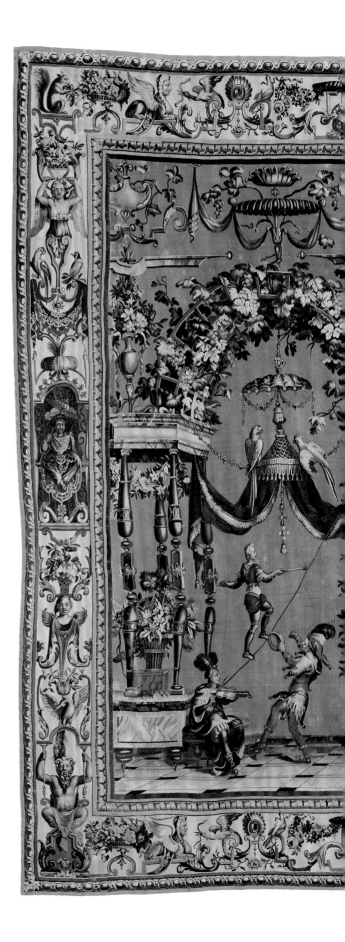

Figure 35
Tapestry, *The Camel* from *The Grotesques*, French (Beauvais manufactory), after the design by Jean-Baptiste Monnoyer (French, 1636–1699), border after the design of Jean-Baptiste Monnoyer and Guy-Louis Vernansal (French, 1648–1729), ca. 1690–1730. Wool and silk, modern cotton lining, 318.8 x 424.2 cm (125½ x 167 in.). Los Angeles, J. Paul Getty Museum, 2003.3

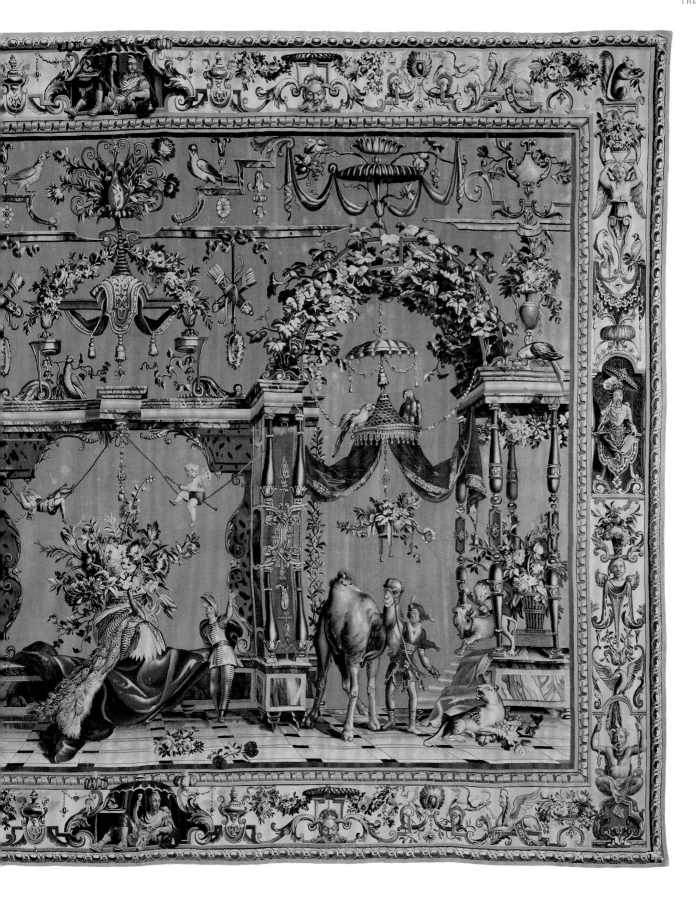

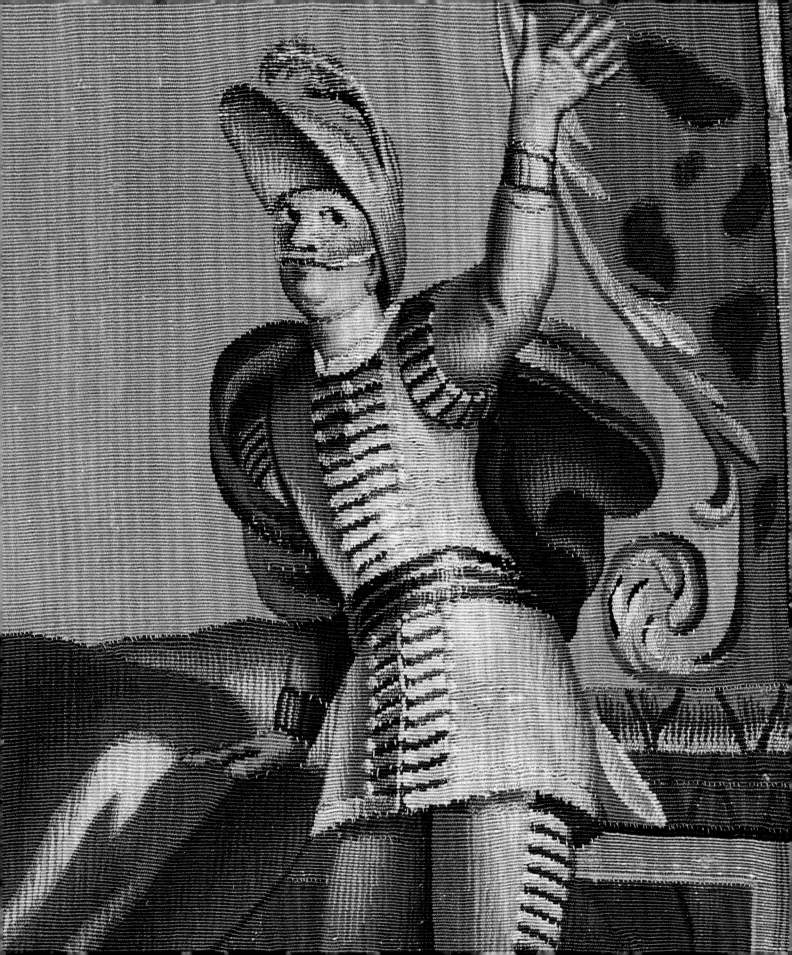

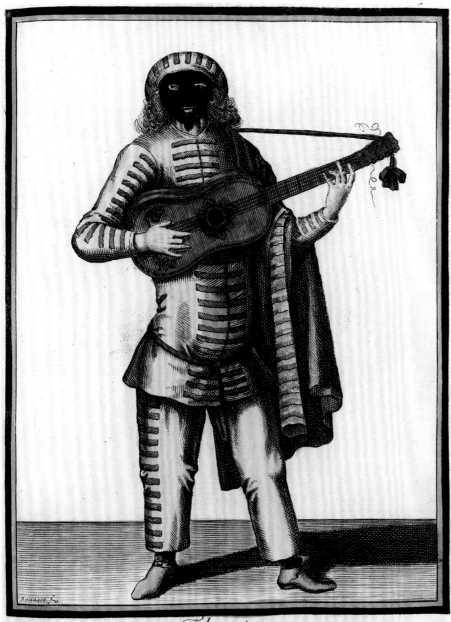

Flautin.

Auec sa Guitarre touchée Il semble qu'il tienne cachée
Plus en maistre qu'en escolier; Vne fluste dans son gosier.
Chez N. Bonnart, rue S.t Iacques, a l'aigle, auec priuil.

Figure 36
Detail of Tapestry, *The Camel* from *The Grotesques* (figure 35)

Figure 37
Nicolas Bonnart (French, 1636–1718), *Flautin* from *Collection of French Court Fashion (Recueil des modes de la cour de France)*, 1678–93. Hand-colored engraving on paper, sheet: 36.5 x 23.8 cm (14 ⅜ x 9 ⅜ in.). Los Angeles County Museum of Art, M.2002.57.156. Purchased with funds provided by The Eli and Edythe L. Broad Foundation, Mr. and Mrs. Reed Oppenheimer, Hal Oppenheimer, Alice and Nahum Lainer, Mr. and Mrs. Gerald Oppenheimer, Ricki and Marvin Ring, Mr. and Mrs. David Sydorick, the Costume Council Fund, and member of the Costume Council

flute or piccolo he normally played in the bawdy repertoire. His costume in the tapestry is composed of an orange-yellow colored suit trimmed with blue corded knots and a cape, which corresponds with contemporary illustrations of the well-known character's signature yellow jacket, pantaloons, and cape (fig. 37).[2] It also corresponds to the signature costume of Sganarelle, the character Molière invented and the role he played in several of his comedies.[3]

The appearance of the tambourine-playing and dancing jester (fig. 39) also refers to theater, specifically to the costume designs of Jean Bérain the Elder. Not only are the stance and attire of the jester in the tapestry similar to the corresponding figure in Bérain's emblematic print of *Season of Winter with the Zodiacal Signs of Capricorn, Aquarius, and Pisces* (see fig. 32), but the color scheme of his outfit—blue, red, and yellow—accords with Bérain's vision for this type of stage character (fig. 38).

Monnoyer drew from quite a diverse mix of artistic precedents when he composed the vignette with the camel (fig. 40). Apart from the world of theater and entertainment, he also found inspiration in ancient Roman monuments. For instance, he based the pose of the animal and

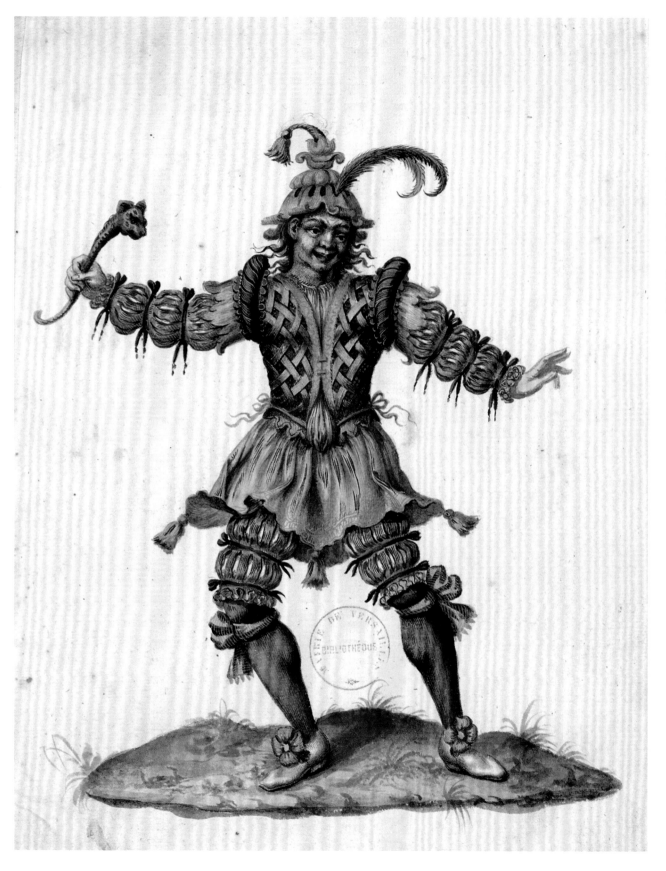

Figure 38
Jean Bérain the Elder
(French, 1640–1711), *Opera:
Male Costume*, ca. 1675–80.
Hand-colored ink drawing
on paper, 26 x 19.5 cm
(10 ¼ x 7 ¾ in.). Bibliothèque
municipal de Versailles, Ms
F 88_E4_11

Figure 39
Detail of Tapestry, *The
Camel* from *The Grotesques*
(figure 35)

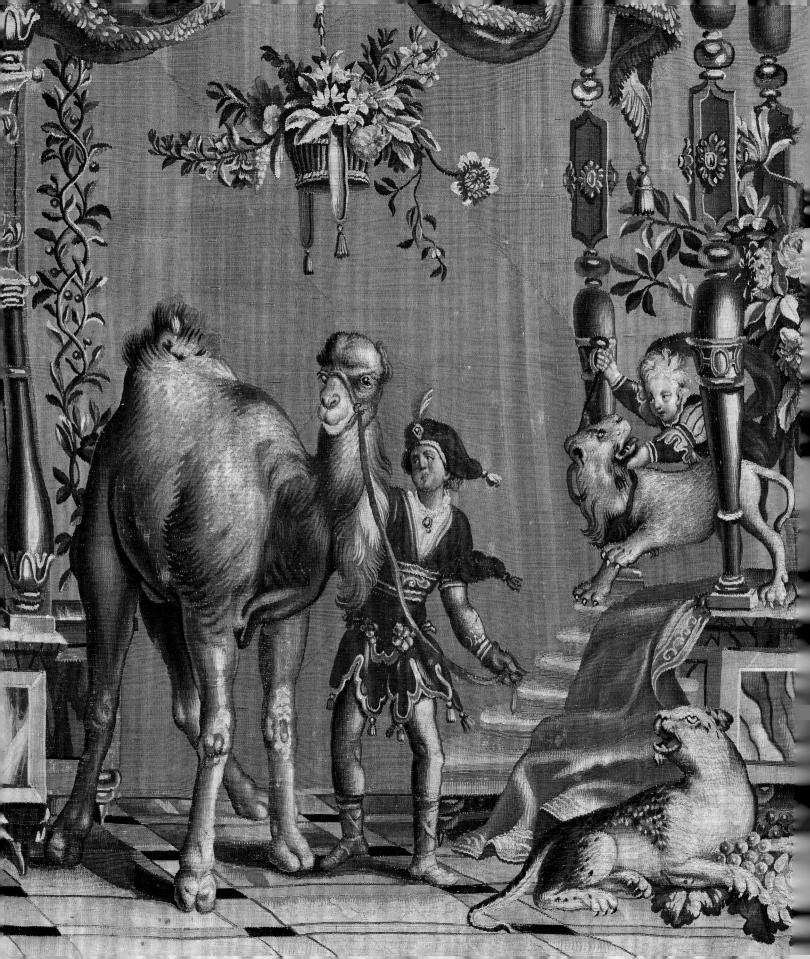

Figure 40
Detail of Tapestry, *The Camel* from *The Grotesques* (figure 28)

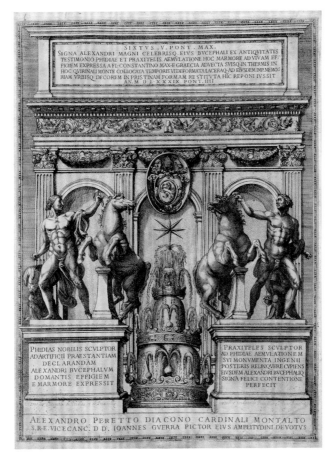

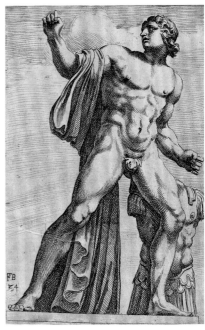

its handler on the most renowned antique sculpture in Rome, the so-called Dioscuri. The enormous monument had been standing in the open since its creation in the fourth century. It consisted of two monumental striding males, sometimes identified as Castor and Pollux and other times as Alexander the Great, that restrain rearing horses. The most likely vehicle of transmission to Monnoyer was an etching showing the *Dioscuri* after its 1589 restoration (fig. 41) that had been included in the compiled album of printed images published under the title *Mirror of Rome's Magnificence*.[4] He also no doubt took note of the line drawing focusing on one of the monument's striding figures from another source, Perrier's 1638 *Antique Statues of Rome* (fig. 42).[5] Illustrations from these works provided Monnoyer with a view of Rome from afar, for he never traveled there himself. Closer to home, the Dioscuri were a noteworthy topic in Paris after a proposal in the 1640s to erect bronze replicas of the statues at the entrance to the Louvre Palace, for which some molds had been prepared.[6]

Monnoyer's substitution of an exotic camel for a horse was a witty twist on a beloved antique monument. For the animal in the tapestry

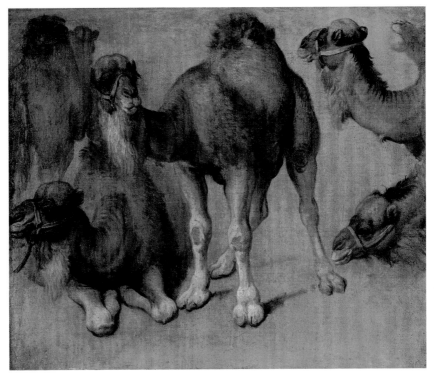

Figure 41
Giovanni Guerra (Italian, ca. 1540–1618), *The Dioscuri Monument* (after 1589) in Antoine Lafréry (French, 1512–1577), *Mirror of Rome's Magnificence* (*Speculum Romanae Magnificentiae*; Rome, 1544?–1602), unnumbered plate. Etching, sheet: 53.6 x 40 cm (21 1/16 x 15 3/4 in.). Los Angeles, Getty Research Institute, 91-F104

Figure 42
One of two plates, *Twins Castor and Pollux* in François Perrier (French, 1594–1649), *Antique Statues of Rome* (*Segmenta nobilium signorum e[t] statu[arum]*; Rome, 1638), plate 24. Engraving, sheet: 34 x 23 cm (13 3/8 x 9 in.). Los Angeles, Getty Research Institute, 82-B2130

Figure 43
Pieter Boel (Flemish, 1622–1674), *Dromedaries*, before 1674. Oil on canvas, 54.5 x 65 cm (21 1/2 x 25 5/8 in.). Paris, Musée du Louvre, inv. 4003, on loan to Reims, Musée des Beaux-Arts, D.892.1.1

Figure 44
Detail of Tapestry, *The Camel* from *The Grotesques* (figure 28)

Figure 45
Pieter Boel (Flemish, 1622–1674), *Triple Study of a Peacock*, before 1674. Oil on canvas, 123 x 199 cm (48½ x 78⅜ in.). Paris, Musée du Louvre, inv. 4032

Figure 46
Detail of Tapestry, *The Camel* from *The Grotesques* (figure 35)

Figure 47
Pieter Boel (Flemish, 1622–1674), *Study of Two Macaw Parrots*, before 1674. Oil on canvas, 126 x 114 cm (49 ⅝ x 44 ⅞ in.). Paris, Musée du Louvre, inv. 4037

cartoon, he consulted the study of dromedaries painted by his colleague Pieter Boel (fig. 43), which had been deposited at the Gobelins, where both artists worked. The Gobelins' stash of animal studies by Boel was a resource that Monnoyer tapped repeatedly: he also copied his colleague's portrayal of a peacock (figs. 44–45) and several poses of brightly colored macaws (figs. 46–47) in this tapestry composition.[7]

NOTES

1. Cowart, *Triumph of Pleasure*, 153.

2. For a roadside scene showing the yellow-suited Flautin performing on a temporary stage, see *Les Charlatans Italiens*, painted in 1657 by Karel Dujardin (Dutch, 1622–1678), musée du Louvre, inventory 1394.

3. Dock, *Costume and Fashion*, 33–44, plate 12.

4. Lafréry et al., *Speculum Romanae Magnificentiae*, unnumbered plate. The *Dioscuri* monument still stands in Rome's Piazza del Quirinale.

5. Perrier, *Segmenta nobilium*, plate 24.

6. Haskell and Penny, *Taste and the Antique*, 136–41.

7. Foucart-Walter, *Pieter Boel*, 77, 108, 129–130, 132; Reyniès, "*The Camel (Le Dromadaire)*," 190–94.

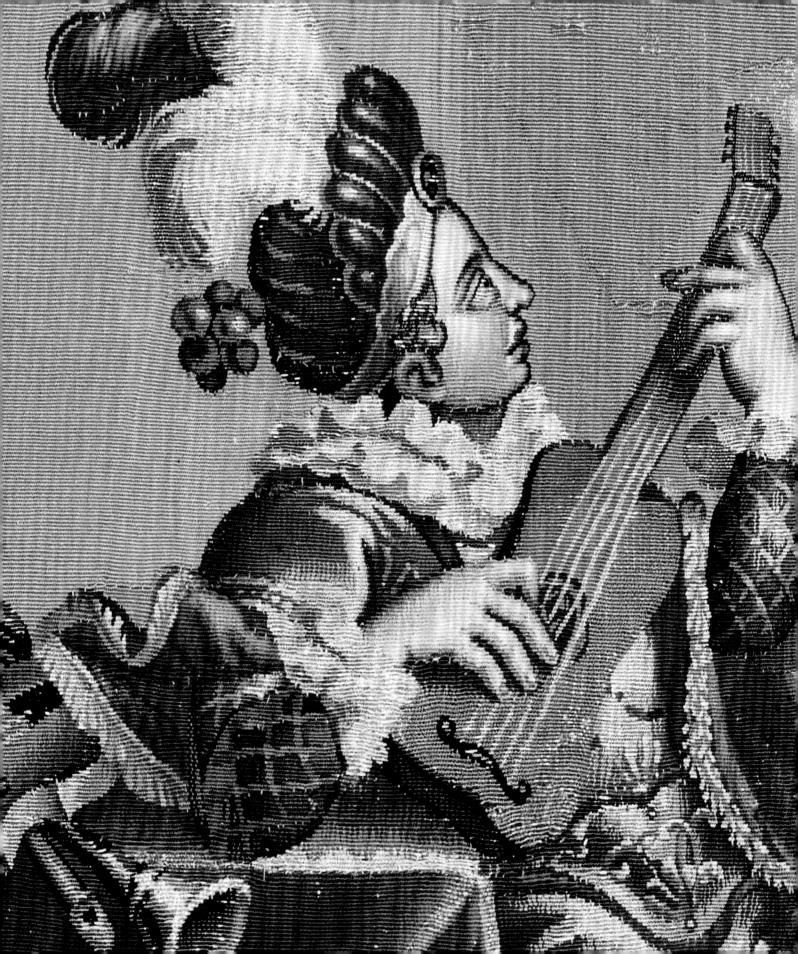

TAPESTRY 4

Musicians and Dancers

Musicians and Dancers was normally the widest tapestry in any set of Beauvais *Grotesques*. Similar in composition to *The Camel* (Tapestry 3), the scene portrays theatrical divertissements under a tripartite arcade set upon a stone-tiled floor (fig. 48). The arcade is composed of a low, segmented plinth, spindly baluster columns and pilasters, a discontinuous architrave, and two lattice arches. Small parasol fixtures hang from each arch. Dangling from each parasol is a succession of ornament, including a tassel; a tied ribbon; and a chain and horizontal rod that, in turn, supports or suspends acanthus scrolls, sensors, swags of blue drapery, a stylized cartouche, and laurel branches. A thick blue curtain, lined with pink, is draped over the architrave of the center section. A hexagonal fixture, with red and white plumes above and

Detail of Tapestry,
Musicians and Dancers
from *The Grotesques*
(figure 48)

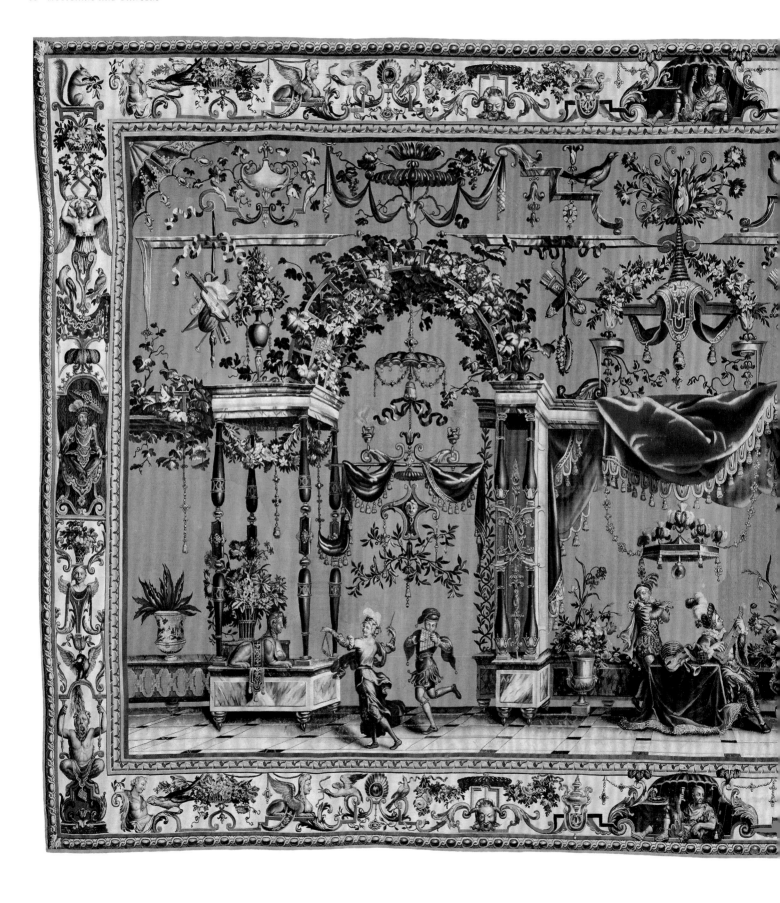

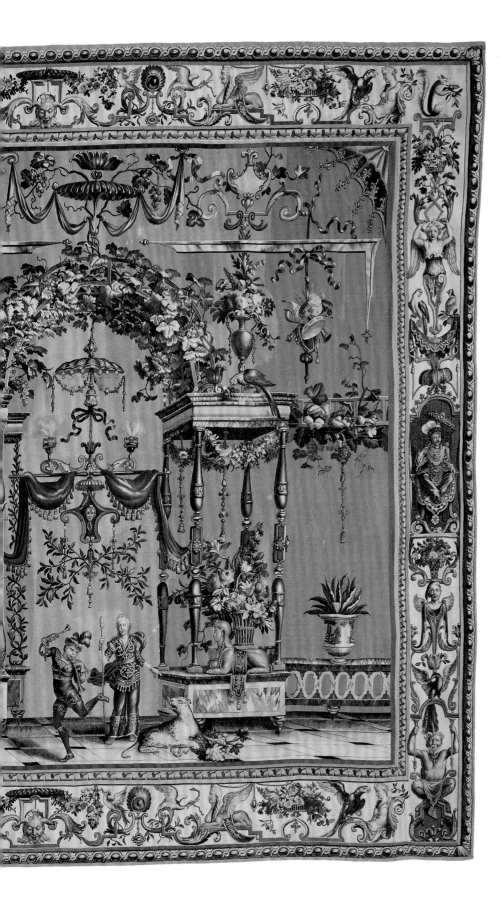

a crystal ball below, hangs by jeweled chains from the architrave. In this weaving, the tripartite construction is extended to the left and right with longer plinth segments, each supporting a stone sphinx and vase of flowers. Farther to the left and right, additional stretches of balustrade carry blue-and-white ceramic urns, each containing an aloe-type succulent. Leafy grape vines and clusters of fruit grow among the lattice frames. A standing female figure points toward a reclining leopard at her feet and holds in her right hand a staff, perhaps a thyrsus. Musicians perform near her: from left to right, figures strike a triangle; play a set of reed pipes, the transverse flute, the guitar, and a straight trumpet; and ring a handbell. The elbow of the guitarist leans on a square table covered with red velvet near a violin and a trumpet. The upper field of

Figure 48

Tapestry, *Musicians and Dancers* from *The Grotesques*, French (Beauvais manufactory), after the design by Jean-Baptiste Monnoyer (French, 1636–1699), border after the design of Jean-Baptiste Monnoyer and Guy-Louis Vernansal (French, 1648–1729), ca. 1690–1730. Wool and silk, modern cotton lining, 316.9 x 522 cm (124¾ x 205½ in.). Los Angeles, J. Paul Getty Museum, 2003.4

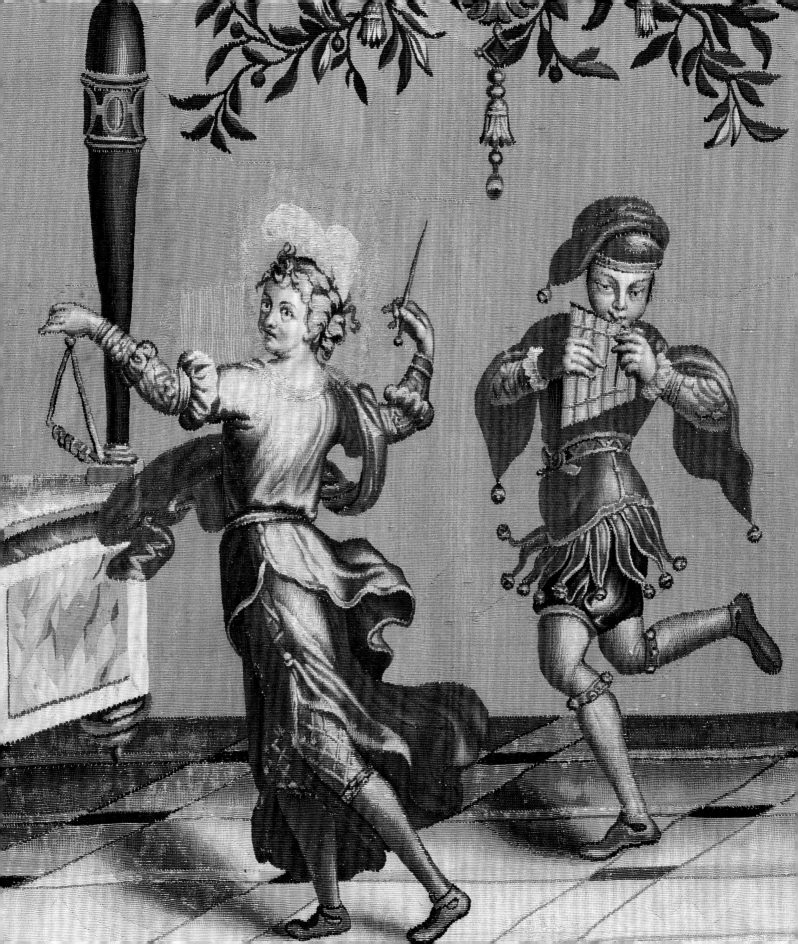

Figure 49
Detail of Tapestry, *Musicians and Dancers* from *The Grotesques* (figure 48)

Figure 50
Agostino Musi, called Agostino Veneziano (Italian, ca. 1490–after 1536), after Raphael (Italian, 1483–1520), *Dance of Fauns and Bacchantes*, 1516. Engraving, plate: 17.1 x 52 cm (6¾ x 20½ in.). Vienna, Graphische Sammlung, Albertina, Alb. It. I. 23, fol. 38

Musicians and Dancers is filled with the same vocabulary of ornament as *The Camel*, with the notable addition of two more trophies: one of musical instruments, including a harp, and sheet music; and the other of additional instruments, a military flag, and a turbaned mask.

VISUAL SOURCES

The composition of *Musicians and Dancers* presents more of Monnoyer's disguised adoptions of Renaissance sources. For instance, the dancing musicians dressed in theatrical costumes (figs. 49 and 51) derive from the music-making fauns and bacchantes engraved by Agostino Musi (called Agostino Veneziano,

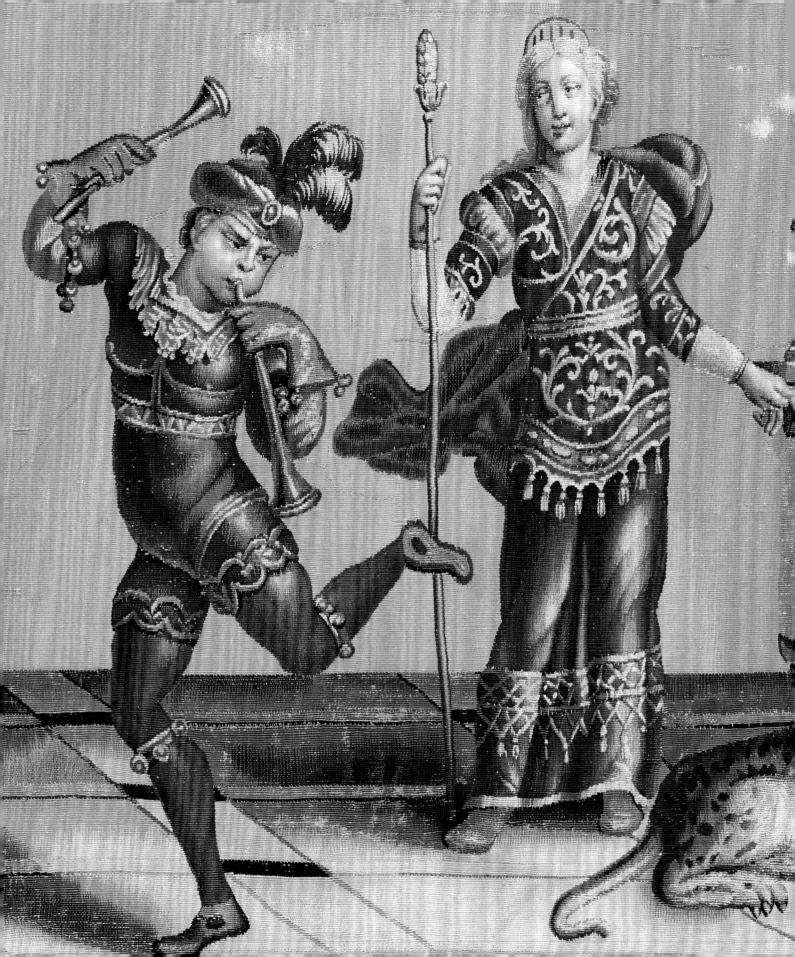

ca. 1490–after 1536) in 1516 after a drawing attributed to Raphael (fig. 50).[1] Note how Monnoyer picked up tricks of perspective from the print, especially the recession of the tiled floor and the shadows of the dancers. He internalized these tricks and applied them successfully to the entire series of *Grotesques* tapestries.

The woman holding a staff and gesturing toward the leopard (fig. 51) was borrowed from a line illustration (fig. 52) in the 1499 book by Francesco Colonna (d. 1527), *Poliphilo's Strife of Love in a Dream* (*Hypnerotomachia Poliphili*), a highly enigmatic Neo-platonic work about love set in a dreamscape with mythological figures. Monnoyer may have known the translated text and been familiar with the original illustrations as reproduced in the book's 1546 French adaptation, *Songe de Poliphile*, by Jean Martin (d. 1553). The garments of Monnoyer's female neatly adhered to Colonna's description of the nymphs accompanying Psyche in a procession: "Next came her companions, in silken garments . . . dyed in tasteful, particoloured shades, in splendidly novel and unusual styles, richly bejeweled. . . . Some had close-fitting bodices of gold scale-work, beautifully and closely ornamented with brilliant gems . . . with artful rinceaux

Figure 51
Detail of Tapestry, *Musicians and Dancers* from *The Grotesques* (figure 48)

Figure 52
One of Psyche's Nymphs from Francesco Colonna (Italian, d. 1527), *La Hypnerotomachia di Poliphil, coiè pugna d'amore in sogno* (1499; Venice, 1545). Woodcut print on paper, sheet: 30 x 20.2 cm (11 ¾ x 7 ¹⁵/₁₆ in.). Los Angeles, Getty Research Institute, 87-B3229

of rare foliage such as the Phrygian embroiders never thought of. . . . They also wore golden tiaras in which the twisted, twofold threads were quite distinct from one another and joined in threefold union . . . [and] they had artful fringes."[2] Given the theatrical nature of the tapestry series and her classically inspired costume, Monnoyer's woven female figure may represent a muse—either Terpsichore, muse of dance and spectacle, or Euterpe, muse of music and pastoral poetry—rather than a nymph.

The flutist in the tapestry descended, via an illustration (see fig. 22), from the antique marble *The Faun Playing the Flute* that Monnoyer had already utilized as a model for the trumpeter in *The Offering to Bacchus* (Tapestry 1).[3] In this case Monnoyer pivoted the figure, hid the lower portion of his body behind the table, and stylized his garments to reflect contemporary ballet and opera (fig. 53).

In the long production span of the Beauvais *Grotesques* tapestries, stone sphinxes were sometimes added to the extreme left and right plinth walls in order to extend the width of two horizontal compositions in the series, *The Camel* and *Musicians and Dancers*. In this example, the sculpture, with carven headdress, rests immediately in front of a tall vase

Figure 53
Detail of Tapestry, *Musicians and Dancers* from *The Grotesques* (figure 48)

Figure 54
Detail of Tapestry, *Musicians and Dancers* from *The Grotesques* (figure 48)

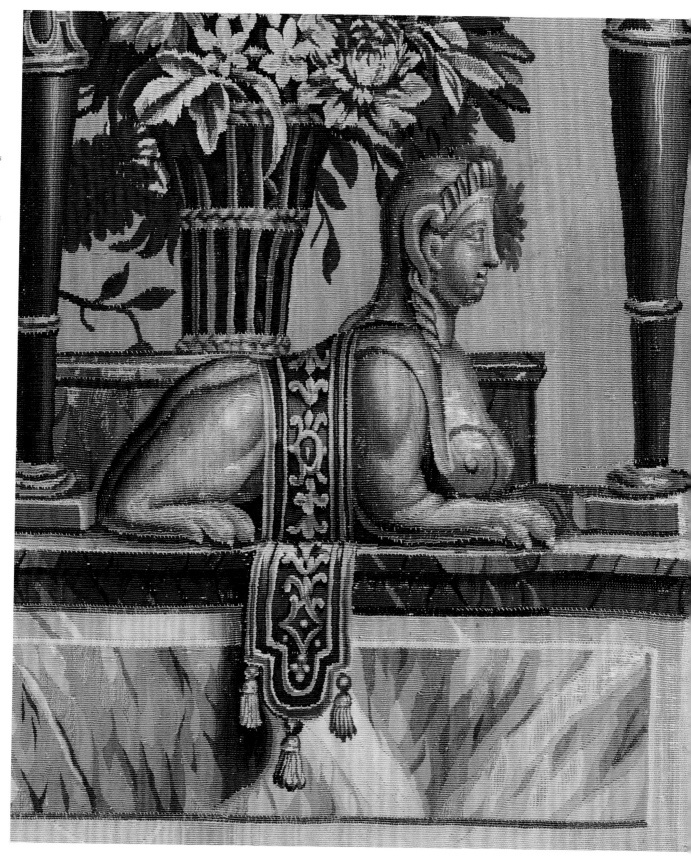

filled with a profusion of flowers (fig. 54). Here, Monnoyer took inspiration from the mythical creature that appeared in the famous massive ancient Roman marble sculpture of a river god personifying the Nile. In the original, the reclining god's left arm and the tall, overflowing cornucopia it held were both propped up by an Egyptian sphinx with a carven headdress. Excavated in Rome before 1523, the antiquity was reproduced in generations of prints throughout the sixteenth and seventeenth centuries, including Perrier's *Antique Statues of Rome* of 1638 (fig. 55).[4] Louis XIV's commission for a marble copy of this work—sculpted in Rome by Lorenzo Ottone (1658–1736) between 1687 and 1692—for the gardens of Marly coincided exactly with Monnoyer's preparation of the *Grotesques* cartoons. Monnoyer surely was aware of the project, but he also would have encountered small-scale bronze reductions of the monument that were by then in circulation in Paris (fig. 56).[5] He toyed with the revered precedent and played with his viewers' visual recognition of it by substituting the vase of flowers for the cornucopia and a narrow embroidered cloth in place of the god's drapery, which, in the original, lay loosely over the sphinx's back.

Figure 55
The Nile, Vatican Gardens in François Perrier (French, 1590–1650, active in Italy), *Antique Statues of Rome (Segmenta nobilium signorum e[t] statu[arum]*; Rome, 1638), plate 93. Engraving, sheet: 34 x 23 cm (13⅜ x 9 in.). Los Angeles, Getty Research Institute, 82-B2130

Figure 56
Attributed to Martin Carlier (French, d. after 1700), *The Nile*, ca. 1700. Leaded bronze, 35.6 x 76.2 x 32.4 cm (14 x 30 x 12¾ in.). San Marino, CA, Huntington Library, Art Collections, and Botanical Gardens, 11.1

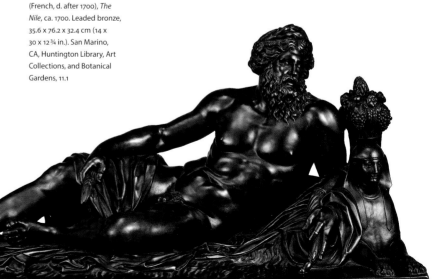

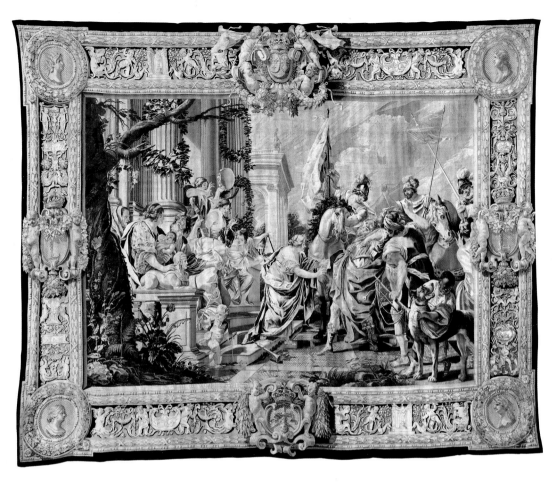

Monnoyer's sphinx in the *Grotesques* tapestries was female. In this gendering as well as in the creature's placement on a pedestal, he followed the example set by Simon Vouet (1590–1649) when he designed, before 1643, the cartoon *The Daughter of Jephthah* for the *Stories of the Old Testament* tapestry series (fig. 57). Monnoyer could have studied Vouet's version either in woven form, from the tapestry in the French royal collection, or in print, from the 1665 engraving by François Tortebat (1616–1690) after the Vouet subject (fig. 58).[6]

Figure 57
Tapestry, *The Daughter of Jephthah* from *Stories of the Old Testament*, French (Paris, Dubout Louvre workshop), after the design of Simon Vouet (French, 1590–1649), before 1643. Wool and silk, 480 x 595 cm (189 x 234 ¼ in.). Paris, Mobilier National, GMTT 23/2

Figure 58
François Tortebat (French, 1616–1690), *The Daughter of Jephthah*, after the design of Simon Vouet (French, 1590–1449), 1665. Etching, 38.1 x 50 cm (15 x 19 ⅝ in.). London, British Museum, 1841,1211.39.6

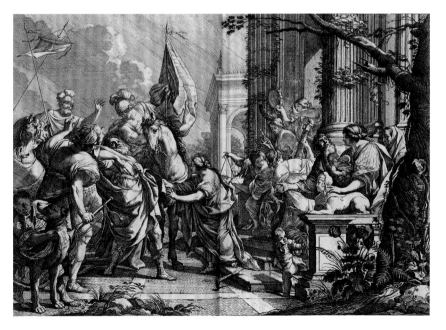

NOTES

1. Oberhuber and Gnann, *Roma e lo stile classico di Raffaello*, 98–99.

2. Colonna, *Hypnerotomachia Poliphili*, 331–36.

3. Perrier, *Segmenta nobilium*, plate 48 (see Tapestry 1, n. 6).

4. Ibid., plates 93–95.

5. Haskell and Penny, *Taste and the Antique*, 272–73. Dating from the first century AD, *The Nile* is in the Musei Vaticani, Rome. cat. 2300. Musei Vaticani database, accessed October 6, 2014, http://www.museivaticani.va/3_EN/pages/x-Schede/ MBNs/MBNs_Sala01_02.html. Lorenzo Ottone's 1680s copy of *The Nile* was transferred to the Tuileries Gardens, Paris, in 1799. Among those who produced bronze reductions around 1679–80 was the sculptor Martin Carlier (active at the French Academy in Rome, 1675–80, d. after 1700). S. Bennett and Sargentson, *French Art of the Eighteenth Century*, 463–66; and Warren et al, *Beauty and Power*, 166–77.

6. Vittet, "*Moses Rescued from the Nile*," 163–69.

CONCLUSION

In designing the cartoons for the Beauvais *Grotesques* tapestry series, Jean-Baptiste Monnoyer practiced the time-honored artistic tradition of *aemulatio*, by which diverse visual sources were given new meaning by juxtaposing them in dialogue.[1] In its most expansive expression, *aemulatio* was more than emulation or imitation. In depicting the thematic program for this series, Monnoyer's efforts revealed his nimble creativity and sophisticated powers of invention. His genius lay not just in borrowing and disguising well-known models and motifs, but also in playfully blending the learned with the lively, the lofty with the lighthearted.

Indeed, Monnoyer's delightful mixture of compositional elements in the *Grotesques* visualized an ephemeral phenomena in the performing arts, as French court ballets and Parisian comedy-ballets responded to and incorporated aspects of popular commedia dell'arte raillery.[2] Monnoyer succeeded in portraying a topical subject—a contemporary evolution in the performing arts, which, by its nature, was "of the moment"—in a style that had its origin in the antique: the persistent and enduring grotesque. Yet his overall presentation was refreshingly new and not the least bit hackneyed. The series had undeniable visual appeal, especially as its subject wasn't somber or moralizing. But the medium of tapestry was relatively expensive and, though a best-seller, sets of Beauvais *Grotesques* tapestries entered into the residences of the wealthy and elite who could afford the luxury of such hangings. For those in the know—that subset of the cultural and intellectual elite—the trendy subject and overt wit of the series were appreciated. With their pastiche of classical subjects and street-fair acrobatics, the tapestries layered content and form, presenting at first glance a charming combination of high- and lowbrow spectacle in a novel format that, upon closer examination, rewarded the cognoscenti with an intriguing play of known artistic antecedents.[3]

NOTES

1. On *aemulatio*, see Brosens, *Rubens*, 163.

2. In 1685, for instance, Jean Bérain the Elder designed costumes for a masquerade at Versailles on the theme of the "Cries of Paris" in which courtiers dressed up as street vendors. See K. Scott, *Rococo Interior*, 132, 288n51.

3. Crow, *Painters and Public Life*, 53. Concerning the identity of the first purchasers of Beauvais *Grotesques* tapestries, see introduction, n. 15.

APPENDIX
Checklist of the Illustrated *Grotesques* Tapestries

The Grotesques

French, Beauvais manufactory

After the design of Jean-Baptiste Monnoyer (French, 1636–1699)

Border after the design of Jean-Baptist Monnoyer and

Guy-Louis Vernansal (French, 1648–1729)

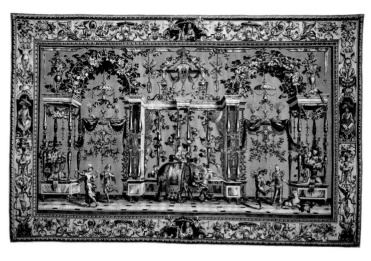

The Elephant
ca. 1690–1711
Wool and silk
294.6 x 459.7 cm (116 x 181 in.)
8 to 9 warps per cm / 20 to 22 warps per inch
New York, Metropolitan Museum of Art, 1977.437.3. Gift of John M. Schiff

PROVENANCE: Reputedly collection of Prince Murat; Jacques Seligmann et Fils, Paris, on consignment as one of five tapestries to French & Company, New York (stock number 3971), February 13, 1917; Mortimer L. Schiff, New York, offered for sale as one of five tapestries by his heir, John M. Schiff, Christie's, London, June 22, 1938, lot 75; John M. Schiff, New York, and consigned temporarily as one of five tapestries to French & Company, New York (stock number 56281-X), 1956–57; Metropolitan Museum of Art, New York, gift of John M. Schiff, 1977, as one of five tapestries

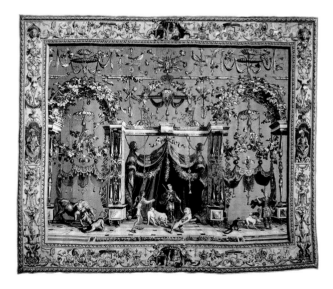

The Animal Tamers
ca. 1688–1719
Wool and silk
336 x 400.5 cm (132 ¼ x 157 ½ in.)
7 to 9 warps per cm / 18 to 22 warps per inch
Schloss Bruchsal, Baden-Württemberg, G 102

PROVENANCE: One of a set of five tapestries, Schloss Bruchsal, since the nineteenth century (possibly earlier, though precisely when the set entered the castle collection is not documented)

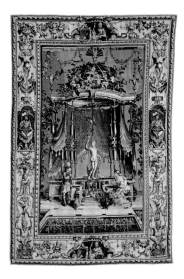

The Offering to Bacchus
ca. 1688–1732
Wool and silk, modern cotton lining
295.3 x 204.5 cm (116 ½ x 80 ½ in.)
8 to 9 warps per cm / 20 to 22 warps per inch
Los Angeles, J. Paul Getty Museum, 86.DD.645

PROVENANCE: Baron A. de Rothschild, sold, London, 1929 (?); one of four
tapestries sold anonymously, Christie's, London, June 22, 1939, lot 159; Frank
Partridge & Sons, London, March 1949; Mrs. John Dewar, sold, Sotheby's,
London, December 16, 1966, lot 15; sold anonymously, Christie's, July 1, 1982, lot 3;
Bernheimer Fine Arts Ltd., London; J. Paul Getty Museum, Los Angeles, 1986

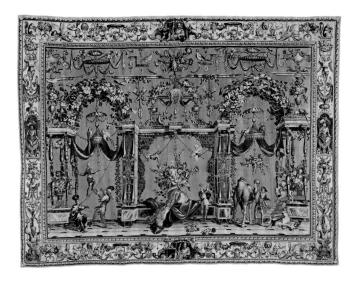

The Camel
ca. 1690–1730
Wool and silk, modern cotton lining
318.8 x 424.2 cm (127 ½ x 167 in.)
8 to 9 warps per cm / 20 to 22 warps per inch
Los Angeles, J. Paul Getty Museum, 2003.3

PROVENANCE: Set of three tapestries, private collection, quai Voltaire, Paris,
from November 3, 1917, to 2001; Galerie Chevalier, Paris, 2001; J. Paul Getty
Museum, Los Angeles, 2003

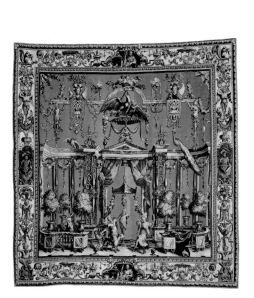

The Offering to Pan
ca. 1690–1730
Wool and silk, modern cotton lining
322.6 x 302.3 cm (127 x 119 in.)
8 to 9 warps per cm / 20 to 22 warps per inch
Los Angeles, J. Paul Getty Museum, 2003.2

PROVENANCE: Set of three tapestries, private collection, quai Voltaire, Paris,
from November 3, 1917, to 2001; Galerie Chevalier, Paris, 2001; J. Paul Getty
Museum, Los Angeles, 2003

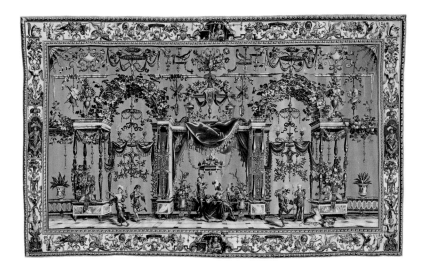

Musicians and Dancers
ca. 1690–1730
Wool and silk, modern cotton lining
316.9 x 522 cm (124 ¾ x 205 ½ in.)
8 to 9 warps per cm / 20 to 22 warps per inch
Los Angeles, J. Paul Getty Museum, 2003.4

PROVENANCE: Set of three tapestries, private collection, quai Voltaire, Paris,
from November 3, 1917, to 2001; Galerie Chevalier, Paris, 2001; J. Paul Getty
Museum, Los Angeles, 2003

BIBLIOGRAPHY

Adelson, Candace J. "*The Camel.*" In *European Tapestry in The Minneapolis Institute of Arts,* 307–21. Minneapolis: Minneapolis Institute of Arts, 1994.

Alciati, Andrea. *Emblemata.* Antwerp: Ex officina Christophori Plantini, architypographi Regij, 1581.

Badin, Jules. *La Manufacture de tapisseries de Beauvais depuis ses origines jusqu'à nos jours.* Paris: Société de Propagation des Livres d'Art, 1909.

Baetjer, Katharine, ed. *Watteau, Music, and Theater.* New York: Metropolitan Museum of Art; New Haven, CT, and London: Yale University Press, 2009. Exhibition catalogue.

Baumstark, Reinhold, and Cornelia Schneider. *Die Bronzen der Fürstlichen Sammlung Liechtenstein.* Frankfurt: Eine Ausstellung des Leibieghauses —Museum alter Plastik in der Schirn Kunsthalle, 1986–87. Exhibition catalogue.

Bennett, Anna G. *Five Centuries of Tapestry from the Fine Arts Museums of San Francisco.* San Francisco: Fine Arts Museums of San Francisco, 1976. Exhibition catalogue.

———. *Five Centuries of Tapestry from the Fine Arts Museums of San Francisco.* Rev. ed. San Francisco: Fine Arts Museums of San Francisco and Chronicle Books. 1992.

Bennett, Shelley, and Carolyn Sargentson, eds., *French Art of the Eighteenth Century at the Huntington.* San Marino, CA: Huntington Library, Art Collections, and Botanical Gardens; New Haven, CT, and London: Yale University Press, 2008.

Bérain, Jean. *L'oeuvre de Bérain, ornemaniste du roy.* Dourdan: Éditions Vial, 2011.

Blunt, Anthony. *Nicolas Poussin: The A. W. Mellon Lectures in the Fine Arts, 1958, National Gallery of Art, Washington, D.C.* London and New York: Phaidon Press in association with Bollingen Series, 1967.

Brejon de Lavergnée, Arnauld, and Jean Vittet, eds. *La tenture d'Artémise: à l'origine des Gobelins; la redécouverte d'un tissage royal.* Collections du Mobilier national. Paris: Mobilier national, Galerie des Gobelins, in association with Éditions de la Réunion des musées nationaux, 2007. Exhibition catalogue.

Bremer-David, Charissa. "*The Camel.*" In Campbell, *Tapestry in the Baroque,* 427–33.

———. "*The Elephant* from *The Grotesques.*" In Brosens et al, *European Tapestries,* 263–67.

———. "*The Emperor Sailing* from *The Story of the Emperor of China.*" In Brosens et al., *European Tapestries,* 272–77.

———. *French Tapestries and Textiles in the J. Paul Getty Museum.* Los Angeles: J. Paul Getty Museum, 1997.

———. "*Les Grotesques: L'Offrande à Bacchus.*" In *French Tapestries and Textiles in the J. Paul Getty Museum,* 72–79.

———. "Manufacture Royale de Tapisseries de Beauvais, 1664–1715." In Campbell, *Tapestry in the Baroque,* 407–19.

———. "Six Tapestries from *L'Histoire de l'empereur de la Chine.*" In *French Tapestries and Textiles in the J. Paul Getty Museum,* 80–97.

———. "*The Triumphs of the Gods.*" In *Woven Gold: Tapestries of Louis XIV.* Los Angeles: J. Paul Getty Museum, 2015. Exhibition catalogue.

Brosens, Koenraad. *Rubens: Subjects from History; The Constantine Series.* Corpus Rubenianum Ludwig Burchard, part 13, vol. 3. London: Harvey Miller, 2011.

Brosens, Koenraad, et al. *European Tapestries in the Art Institute of Chicago.* Edited by Christa C. Mayer Thurman. Chicago: Art Institute of Chicago; New Haven, CT: Yale University Press, 2008.

Campbell, Thomas P. "Designs for the Papacy by the Raphael Workshop, 1517–30." In *Tapestry in the Renaissance,* 225–29.

———. *Tapestry in the Renaissance: Art and Magnificence.* New York: Metropolitan Museum of Art; New Haven, CT, and London: Yale University Press, 2002. Exhibition catalogue.

Campbell, Thomas P., ed. *Tapestry in the Baroque: Threads of Splendor.* New York: Metropolitan Museum of Art; New Haven, CT, and London: Yale University Press, 2007. Exhibition catalogue.

Colonna, Francesco. *Hypnerotomachia Poliphili: The Strife of Love in a Dream.* Translated by Joscelyn Godwin. London: Thames & Hudson, 1999.

Cowart, Georgia J. *The Triumph of Pleasure: Louis XIV and the Politics of Spectacle.* Chicago and London: University of Chicago Press, 2008.

Crow, Thomas. *Painters and Public Life in Eighteenth-Century Paris.* New Haven, CT, and London: Yale University Press, 1985.

Dobney, Jayson Kerr. "Violin, '*The Francesca.*'" In Baetjer, *Watteau, Music, and Theater,* 132–33.

———. "Guitar." In Baetjer, *Watteau, Music, and Theater,* 133–34.

———. "*Musette de cour.*" In Baetjer, *Watteau, Music, and Theater,* 134–35.

———. "Oboe." In Baetjer, *Watteau, Music, and Theater,* 136–37.

———. "Transverse Flute." In Baetjer, *Watteau, Music, and Theater,* 138–39.

Dock, Stephen Varick. *Costume and Fashion in the Plays of Jean-Baptiste Poqueline Molière: A Seventeenth-Century Perspective.* Geneva: Editions Slatkine, 1992.

Félibien, André. *Entretiens sur les vies et sur les ouvrages des plus excellents peintres anciens et moderns.* 4 vols. Paris: Pierre le Petit, 1666–85. Reprint, Geneva: Minkoff Reprint, 1972.

Forti Grazzini, Nello. "*The Triumph of Venus*." In Campbell, *Tapestry in the Baroque*, 397–405.

Foucart-Walter, Elisabeth. *Pieter Boel, 1622–1674: peintre des animaux de Louis XIV*. Les dossiers du musée du Louvre. Paris: Éditions de la Réunion des musées nationaux, 2001.

Frick Collection. "Major Gift of Sculpture Placed on View at The Frick Collection, Giovanni Francesco Susini's *Lion Attacking a Horse* and *Leopard Attacking a Bull*." Press release, May 20, 2003. Accessed January 26, 2014. http://www.frick.org/press/.

Furetière, Antoine. *Dictionnaire universel, contenant généralement tous les mots*. 3 vols. The Hague and Rotterdam: Arnout & Reinier Leers, 1690. Accessed December 16, 2013. http://books.google.com/books.

Grouchy, Emmanuel Henri, vicomte de. "Notes sur les tapisseries aux XVIIe et XVIIIe siècles: recueillies dans les minutes des notaries; vente de tapisseries par Philippe Béhagle, entrepreneur de la manufacture de Beauvais (2 avril 1689)." *Nouvelles archives de l'art français*, 3rd ser., 8 (1892): 62–64.

Guiffrey, Jules. *Inventaire général du mobilier de la Couronne sous Louis XIV (1663–1715)*. 2 vols. Paris: La Société d'encouragement pour la propagation des livres d'art, 1885–86.

Haskell, Francis, and Nicolas Penny. *Taste and the Antique: The Lure of Classical Sculpture, 1500–1900*. New Haven, CT, and London: Yale University Press, 1981. Reprint, 1998.

Iacopi, Irene. *Domus Aurea*. Rome: Electa, 1999.

Lafréry, Antoine, et al. *Speculum Romanae Magnificentiae*. Rome, 1544?–1602.

La Gorce, Jérôme de. *Berain, dessinateur du Roi Soleil*. Paris: Éditions Herscher, 1986.

Lully, Jean-Baptiste. *Le carnaval, mascarade*. Paris: J-B-Christophe Ballard, 1720. Accessed October 3, 2013. http://gallica.bnf.fr/.

———. *Le carnaval, mascarade royale*. Paris: Robert Ballard, 1680. Accessed December 31, 2013. http://jean-claude.brenac.pagesperso-orange.fr/LULLY_CARNAVAL.htm/.

Maral, Alexandre, and Nicolas Milovanovic. *Versailles et l'antique*. Versailles: Château de Versailles, 2012. Exhibition catalogue.

Müntz, Eugéne. *Les tapisseries de Raphaël au Vatican et dans les principaux musées ou collections de l'Europe: Étude historique et critique*. Paris: J. Rothschild, 1897.

Musée du Louvre. Atlas database. Accessed May 14, 2015. http://cartelen.louvre.fr.

Musée du Louvre. Notices database. Accessed May 14, 2015. http://www.louvre.fr/en/oeuvre-notices/eliezer-and-rebecca/.

Musei Vaticani. Collection database. Accessed October 6, 2014, http://www.museivaticani.va/3_EN/pages/x-Schede/MBNs/MBNs_Sala01_02.html.

Oberhuber, Konrad, and Achim Gnann. *Roma e lo stile classico di Raffaello*. Mantua: Palazzo Te; Vienna: Graphische Sammlung Albertina, 2009. Exhibition catalogue.

Pardailhé-Galabrun, Annik. *The Birth of Intimacy: Privacy and Domestic Life in Early Modern Paris*. Translated by Joselyn Phelps. Philadelphia: University of Pennsylvania Press, 1991.

Pazzis-Chevalier, Nicole de. *Quand grotesque signifie fantaisie, charme et séduction: catalogue édité à l'occasion de la XXIe Biennale des Antiquaires (Paris, 20–29 Septembre 2002)*. Paris: Galerie Chevalier, 2002.

Perrier, François. *Segmenta nobilium signorum e[t] statu[arum]*. Rome, 1638.

Pliny the Elder. *The Natural History*. Perseus Digital Library. Accessed February 12, 2015, http://www.perseus.tufts.edu/hopper/text?doc=urn:cts:latinLit:phi0978.phi001.perseus-eng1:10.31.

Reyniès, Nicole de. "*The Camel (Le Dromadaire)* from the series *Grotesques* with a Yellow Ground." In *The Toms Collection: Tapestries of the Sixteenth to Nineteenth Centuries*, by Guy Delmarcel, Nicole de Reyniès, and Wendy Hefford, edited by Giselle Eberhard Cotton, 190–94. Lausanne: Fondation Toms Pauli; Sulgen: Niggli, 2010.

Salmon, Xavier. *Le Triomphe de Vénus par Noël Coypel, un carton de tapisserie redécouvert*. Dijon: Éditions Faton, 2011.

Salvi, Claudia. *D'après nature: la nature morte en France au XVIIe siècle*. Tournai: La Renaissance du Livre, 2000.

Scott, Katie. *The Rococo Interior: Decoration and Social Spaces in Early Eighteenth-Century Paris*. New Haven, CT, and London: Yale University Press, 1995.

Scott, Virginia. *The Commedia dell'Arte in Paris, 1644–1697*. Charlottesville: University Press of Virginia, 1990.

———. *Molière: A Theatrical Life*. Cambridge: Cambridge University Press, 2000.

Scuola Normale Superiore di Pisa. "The Reception of Antique Statuary in Collections of Engraving." *Monumenta Rariora*. Accessed September 11, 2013. http://mora.sns.it/_portale/.

Standen, Edith Appleton. "Berain Grotesques." In *European Post-Medieval Tapestries and Related Hangings in the Metropolitan Museum of Art*, vol. 2, 441–58. New York: Metropolitan Museum of Art, 1985.

Stockholm360.net. "The Oval (City Hall) Stockholm, Sweden." Virtual tour. Accessed December 30, 2013. http://www.stockholm360.net/fp.php?id=ch-ovalen2.

Stratmann-Döhler, Rosemarie. "Groteskenfolge." In *Tapisserien: Wandteppiche aus den staatlichen Schlossern Baden-Württembergs*, by Carla Fandrey et al., 55–62. Vol. 6 of *Schätze aus unseren Schlössern: Eine Reihe der Stattlichen Schlösser und Gärten Baden-Württemberg*. Weinheim: Edition Diesbach, 2002.

Verdi, Richard. *Nicolas Poussin, 1594–1665*. Paris: Galeries nationales du Grand Palais; London, Royal Academy of Arts, in association with Zwemmer, 1994–95. Exhibition catalogue.

Vittet, Jean. "Example d'un ameublement: Décor textile de l'antichambre du Grand Couvert, Tenture de La Galerie de Saint-Cloud." In *Le château de Versailles raconte le Mobilier national: Quatre siècles de creation*, by Jean-Jacques Gautier and Bertrand Rondot, 126–131. Versailles: Château de Versailles, 2011. Exhibition catalogue.

———. "*Moses Rescued from the Nile*." In Campbell, *Tapestry in the Baroque*, 163–69.

Vittet, Jean, ed. *La tenture de l'histoire d'Alexandre le Grand*. Collections du Mobilier national. Paris: Mobilier national, Galerie des Gobelins, in association with Éditions de la Réunion des musées nationaux, 2008. Exhibition catalogue.

Warren, Jeremy, et al. *Beauty and Power: Renaissance and Baroque Bronzes from the Peter Marino Collection*. London: Wallace Collection; San Marino, CA: Huntington Art Collections; Minneapolis: Minneapolis Institute of Arts, 2010–11. Exhibition catalogue.

Weigert, Roger-Armand. *Le décor Berain*. Aix-en-Provence: Musée des Tapisseries, 1954. Exhibition catalogue.

———. "Les Grotesques de Beauvais." *Hyphé* 1 (January–February 1946): 66–73.

———. "Les Grotesques de Beauvais et les tapisseries de Chevening (Kent)." *Bulletin de la Société de l'histoire de l'art français* (1933): 7–21.

———. "Inventaire des tapisseries de Charles-Maurice Le Tellier archevêque de Reims (1710)." *Archives de l'art français*. Nouvelle periode, vol. 21 (1949): 21–27.

———. *Jean I Berain, dessinateur de la chambre et du cabinet du roi (1640–1711)*. 2 vols. Paris: Les Éditions d'art et d'histoire, 1937.

Weigert, Roger-Armand, and Carl Hernmarck, eds. *Les relations artistiques entre la France et la Suède, 1693–1718: Nicodème Tessin le jeune et Daniel Cronström correspondance (extraits)*. Stockholm: Engellska Boktryckeriet, 1964.

Wine, Humphrey. "*The Triumph of Pan*." In *National Gallery Catalogues: The Seventeenth-Century French Paintings*, 350–65. London: National Gallery Company; New Haven, CT, and London: Yale University Press, 2001.

Published by the J. Paul Getty Museum, Los Angeles

Getty Publications

1200 Getty Center Drive, Suite 500

Los Angeles, California 90049-1682

www.getty.edu/publications

Tom Fredrickson, *Editor*

Kurt Hauser, *Designer*

Amita Molloy, *Production*

Distributed in the United States and Canada by the University of Chicago Press

Distributed outside the United States and Canada by Yale University Press, London

Printed in Hong Kong

Library of Congress Cataloging-in-Publication Data

Bremer-David, Charissa, author.

 Conundrum : puzzles in the Grotesques tapestry series / Charissa Bremer-David.

 pages cm

 Includes bibliographical references.

 ISBN 978-1-60606-453-5 (pbk.)

1. Grotesques. 2. Tapestry—France—Beauvais—History—

17th century. 3. Tapestry—France—Beauvais—History—18th century.

4. Manufacture nationale de tapisserie de Beauvais (France) 5. Tapestry—Themes,

motives. 6. J. Paul Getty Museum. 7. Tapestry—California—

Los Angeles. I. J. Paul Getty Museum, issuing body. II. Title.

 NK3049.G76B74 2015

 746.3944'2609032—dc23

 2014044317

Front cover: Detail of Tapestry, *Musicians and Dancers* from *The Grotesques* (figure 48)

Front flap: Detail of *Flautin* (figure 37)

Back cover: Detail of Tapestry, *Musicians and Dancers* from *The Grotesques* (figure 48)

Half title: Detail of Tapestry, *The Camel* from *The Grotesques* (figure 35)

Title page: Detail of Tapestry, *The Camel* from *The Grotesques* (figure 35)

Page 4 (facing Table of Contents): Detail of Tapestry, *Musicians and Dancers* from *The Grotesques* (figure 48)

Page 6 (facing Foreword): Detail of Tapestry, *Musicians and Dancers* from *The Grotesques* (figure 48)

Page 8 (facing Introduction): Detail of Tapestry, *The Offering to Pan* from *The Grotesques* (figure 28)

Illustration Credits

Every effort has been made to contact the owners and photographers of objects reproduced here whose names do not appear in the captions or in the illustration credits listed below. Anyone having further information concerning copyright holders is asked to contact Getty Publications so this information can be included in future printings.

Figure 1: Photo by Eugenio Monti, Soprintendenza Archeologica di Roma, with Studio Cozzi-Scribani

Figures 3, 57: © Lawrence Perquis

Figure 4: Collection du Mobilier national © Philippe Sébert

Figure 6: © RMN–Grand Palais / Art Resource, NY / Bulloz

Figure 8: © RMN–Grand Palais / Art Resource, NY / Philippe Fuzeau

Figures 9, 10: © The Metropolitan Museum of Art / Art Resource, NY

Figure 11: Royal Collection Trust © Her Majesty Queen Elizabeth II, 2014 / Bridgeman Images

Figure 13: © RMN–Grand Palais / Art Resource, NY / Daniel Arnaudet / Gérard Blot

Figure 14: Photo by Nationalmuseum, Stockholm

Figure 16: Landesmedienzentrum Baden-Württemberg, Arnim Weischer

Figure 17: © The Frick Collection, New York

Figures 21, 34: © RMN–Grand Palais / Art Resource, NY / Hervé Lewandowski

Figure 23: © Maryvonne Gilotte / Bridgeman Images

Figures 27, 58: © The Trustees of the British Museum / Art Resource, NY

Figure 30: © National Gallery, London / Art Resource, NY

Figure 37: © 2015 Museum Associates / LACMA / Art Resource, NY

Figure 38: © Bibliothèque municipale de Versailles, France, Ms F 88_E4_11

Figure 43: © RMN–Grand Palais / Art Resource, NY / Gérard Blot

Figures 45, 47: © RMN–Grand Palais / Art Resource, NY / René-Gabriel Ojéda

Figure 50: Albertina, Vienna

Figure 56: © Courtesy of the Huntington Art Collections